well I just kind of like it

well I just kind of like it
art in the home and the home as art

edited by Wendy Erskine

Published by PVA Books

INTRODUCTION
Wendy Erskine

Well I just kind of like it, says a person when asked about a particular piece of art in their home. Maybe this is said with insouciance and a shrug. Because really, what more is necessary than an assertion of their own approval? But perhaps the tone is a little tentative, even defensive. They feel self-conscious and ill-equipped to talk about art. It's the kind of thing to be treated with reverence in vast hushed spaces, the stuff produced by those with special category status, owing to their preternatural keenness of vision and depth of understanding. It's hard to know what to say, or why they bought it. So many considerations, really. Perhaps it only cost £9.99. How might this piece of art be regarded by those who link worth to monetary value? And what about taste consensus? Is this piece of art the work of someone regarded as dreadful by aesthetic arbiters? Who knows, perhaps the person, on a visit to a gallery, may well have had an intimidating encounter with the type of art writing decried by William Empson as a 'steady iron-hard jet of absolute nonsense'. It left them baffled and thinking that 'art' was somehow beyond them.

And yet, whether or not they want to talk about it, are suspicious of it, say they don't understand it, people's homes are full of art that is deeply important to them and with which they interact and engage in a multitude of ways. That is partly what this book explores.

It also considers the home as art. Quilts, peeling wallpaper, kitchens, bedrooms, a slice of ham on a worktop: all of these appear in the artists' work that you will encounter. And perhaps, you might end up looking anew at the quotidian stuff of your own home and, in the act of noticing, it'll seem different. That fruit bowl, a still life. Those rumpled white sheets in the wash-basket, a thing of wonder.

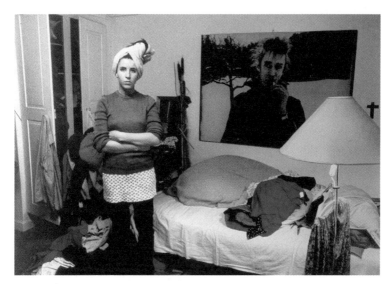

Annelies Ŝtrba, *Linda and Blixa*, 1990. C-print. Courtesy of the artist.

GARRET
Darran Anderson

What art there was seemed to have always been there. It was
there before I was. Only later, when I'd left that home and
could never darken its doors again, did I realise my parents
had assembled it. They were the most unlikely of curators,
never seeing themselves as such, and therefore the most
natural. And it was the most unlikely of galleries, in austere
rooms in a tumbledown house in a burning city. Yet there
it was. A secret to passers-by on the street, afternoon men
staggering from the pub, army patrols snaking between lamp
posts, boys on errands.

Thirty years later, blessed and cursed with a spatial
memory, I can walk through the rooms as if I am still there;
an apparition in the memory-world just as they, the lost,
appear as ghosts to us. I take note of the art. In the hall, by
the door, above my father's bicycle, there is a pagan sculpture
of the Green Man, jolly as a Toby jug, so antithetical to the
nuns and priests of my school they'd have hissed at it. In the
front room, above the mattress on the floor where my uncle
slept, having been recently deported from the United States,
in two alcoves either side of a boarded-up fireplace, was
a collection of chinoiserie bric-a-brac – swirling dragons,
hand-painted eggshells, unfurled fans, woodblock prints of
the moon. In the living room, above the mantelpiece was a
large hallucinatory canvas of hippy art, made by the same
artist (Mati Klarwein as I found out later) who created several
album covers (*Bitches Brew, Abraxas*) I fixated over in my
dad's dusty record collection. Opposite, above the coal
bunker under the stairs, were four therianthropic depictions
of the Evangelists from the *Book of Kells* – Celtic Christian
psychedelia featuring a winged apostle, a humanoid lion, ox,
and eagle. This was another Christianity entirely.

11

On the stairs were fairy-tale pictures from Victorian books, mostly watercolours by Arthur Rackham, showing a teeming arcadian world below ours, alluring and dangerous as temptation. On the landing, grainy portraits of the blues singers Robert Johnson, Muddy Waters, Howlin' Wolf, another world again, reaching across a crackling ocean of time. In my room, a painting of the Four Horsemen of the Apocalypse, the painter and provenance of which I've never been able to establish. In my parent's room, a hazy image of the lovelorn commedia dell'arte clown Pierrot. Above their door, a glimmering portrait of an Indian prince and princess in a howdah on the back of an elephant painted onto a peepal leaf, fallen from the kind of tree Buddha sat under. And opposite on the landing, an Art Nouveau-style poster from an Irish music festival by the sea, a Celtic/Pre-Raphaelite maiden with her tresses reaching out over the crowd. The festival was cancelled that same year when five young men drowned, carried off by riptides. Three of them were brothers. A few years later, a freak storm came and washed away the beach.

It took me a long time to realise these treasures were all junk. Later still, I realised their value; it is worthless things that are priceless. My folks lived an interstitial life and they collected that which fell through the cracks, things that became treasures through scarcity, items that brought colour into a world that had been drained of it. They never said this to me directly, letting the objects speak, but the message they were conveying was 'The earth is not just this.'

For all their fascination, none of the works captivated me quite as much as one that loomed high above, out of reach. A wooden square, in a frame, painted white. My own personal Malevich. It would stretch all definitions to call it art but perhaps that is the point. If a porcelain urinal could be a readymade then why not an attic door?

Eventually, it was possible to clamber onto the banisters and, at a stretch, flick the latch and push the door (what they

used to call the scuttle hole) upwards and off to the side. In its place was now a void, which felt like gazing not upwards but downwards. It was only on my third or fourth attempt, worried that I'd be startled and topple cartwheeling down the stairs, that I was able, arms trembling with the strain, to pull myself up into the loft.

What I expected to find there, I do not know. I was an insatiably bookish boy. My head rattled with more literary detritus than any attic could hold. Given the modesty of our circumstances, there wasn't much choice in reading material. Once I'd exhausted whatever novels could be found, I would consume old miscellanies – *Pears' Shilling Cyclopaedia*, *Chambers's Information for the People*, *The New Universal Handbook of Necessary Information*. I did not understand half of what I read but I delved regardless, to feed the appetite. One of the consequences was that I came to know of many books without directly reading them, having to conjure up my own distorted versions from the scraps I could find. Among the threads I picked up, several led upwards to the attic. It was a place where spiders, rats, and ghouls dwelt, a place of evil paintings and moth-eaten crones, where shameful secrets were locked, and the unwanted immured. It was also the place where treasure maps might be found. I was still naïve enough to see the world through a Gothic prism, to assume that evil would look like evil and not its opposite. The attic, by contrast, tells us little of itself and everything about the rooms in the house that are not the attic.

In a sense, attics are the most innocent of spaces, just as graveyards are the most feared but often the safest parts of a city because the living rarely go there. Nevertheless, they are haunted places. Being made into a repository of memory, overloaded with the past, did something to the unconverted loft. It was the one room in the house that didn't fit. A room where it was always night. A barrier that protected the rest of the house but where the creatures and sounds of the outside

world nevertheless seemed to permeate. A room where a single misstep could result in falling through the floor, like breaking the surface of the sea or the silence of the past.

There were advantages to this hidden place, some nefarious. Calling around to a friend's house, as boys, we were waiting for an 8-bit game to load from its cassette, when I heard a sudden creaking above and asked if they had mice.

'That's my uncle,' he replied. 'He lives up there now. He's not really my uncle. He's on the run. You're not to tell anyone.'

I stared at him for a few seconds as my comprehension caught up with his words, by which time he'd given me a dead arm just to make sure I didn't squeal.

By the time my friends and I reached adolescence, there was nowhere for us to go and, suddenly conspicuous, we started to attract unwanted attention from the RUC, the army, roaming packs of scallies, and occasionally, adding local colour, paramilitaries. We found refuge in derelict warehouses, condemned ruins, and building sites for years, which were difficult to access, with innumerable obstacles for us but also any interlopers. Even these ran the risk of being spotted from afar or encountering guard dogs and nightwatchmen. After too many close calls, chased across rooftops, weaving through abandoned machinery, jumping over colossal drops, torches wildly lurching, dogs snapping at our heels, we sought sanctuary in the attics of the buildings, nestled under the slates, where no one could see us. We would set up shrines of candles under the rafters and sit for hours cocooned in the flickering half-light in varying states of intoxication. The only problem was, as we would find out, if there was only one way in, there was only one way out.

A decade later and I was living in another city, another life, across the sea. I'd long forgotten about the attic spaces we'd inhabited, when I chanced upon an art exhibition by Janet Cardiff and George Bures Miller one afternoon in what had

been an old fruit and vegetable market. In one room, there was a torture machine resurrected from the pages of Kafka's 'In the Penal Colony'. In another, a shack, inside which an invisible opera lover played his collection through a series of gramophones. And upstairs was something called *The Dark Pool*. It was unlike anything I'd ever seen in a gallery. A work of art in the form of a room, a hermitage left abandoned by a recluse, drawers full of esoteric writings, piles of books lit by swinging light bulbs, a mannequin's head, a typewriter, mysterious utterances from speakers. It was hard to believe someone had created rather than lived this.

At the time I'd strained my hamstring and was hobbling around on a crutch. Emerging from the gallery, I was forced to take respite sitting on a flight of stone steps that wound their way up towards the castle above town, one of the unwanted yet regular 'thinking time' moments the injury had gifted me. I found my mind drifting back to the attic I'd climbed up into as a boy. I had felt the exact same feeling in there as I had walking through *The Dark Pool*, a feeling of moving through a portal into somewhere impossibly numinous and intimate. I wondered, what separated that attic from being art? A lack of intention perhaps but what if the power to name something as art, to sanctify it, didn't just belong to the high priests of the discipline? What if anyone could do it? Perhaps it was something that children did anyway and was just something most of us misplaced along the way.

It started to rain, and I sidled over, taking shelter under an archway that seemed to be the sealed back door of a nightclub. Soon it was torrential, cascading down the steps. Someone had come to a window in a tenement high above and was looking out at the deluge before vanishing. I settled down to wait for the squall to pass. I closed my eyes, and I could hear the rain that fell a decade earlier on the tiles of that lost home, a lullaby in the attic dark. If that place resembled an artistic

assemblage, an immersive 'found environment', could it really be a work of art if it was not public? Did anyone else have to know, and assent, for art to be art? Could there be private or even secret works of art? Such thoughts passed the time as the rain kept falling.

In the end, the suspended animation of the attic was not what it seemed. Time moved more slowly there but it still moved. It could not be stopped or kept out. Paper mouldered in the damp. Mice ate through fabrics. The past slowly eroded in its storage.

It is a mystery to me who lives in that childhood house now, and what objects now inhabit that space in the loft. Returning to my hometown last year between lockdowns, I went for a walk and passed a gatehouse at the beginning of a track that wound down to the river from where we had lived. It was derelict even back then. The first girl I ever courted knew a way to get inside and we'd go there, throwing pebbles at each other's bedroom windows before setting off together. In the attic of the gatehouse was a skylight. They used to call such places garrets from the old French for 'watchtower'.

The gatehouse is still there now, empty and ruined. The roof has partially caved in. Each night, constellations move across the sky. The stars of Cassiopeia, Cepheus, Draco, Ursa Major, and Ursa Minor are framed, at different times and angles, in that hole in that roof, their light travelling across barely imaginable spaces to reach that attic. No one will be there to see it in that desolate secret place and, if you take my word for it, it will be as much a work of art as any other.

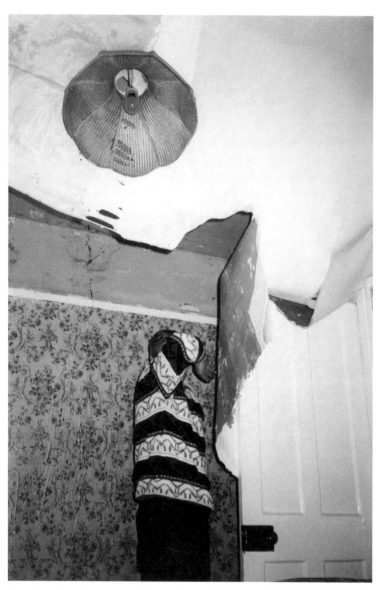

Photo: Jan McCullough

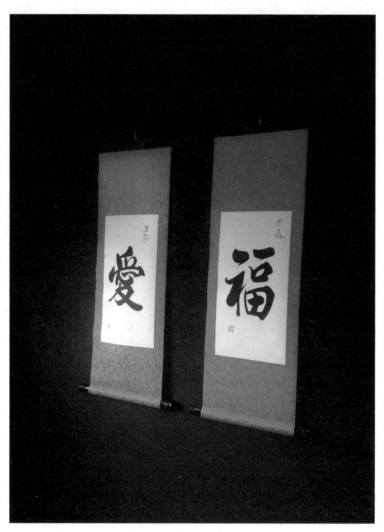

Courtesy of the author

TWO SCROLLS: GOOD LUCK AND LOVE
Rossa Coyle

Beijing on a late autumn day in 2012.

Hungover and drifting along through the crowds towards the Forbidden City.

We were in China for our friends' wedding with a big group and afterwards had travelled from Changsha to Beijing on an overnight train. Any romantic notions about a private cabin on the train were quickly erased by the arrival of a young woman with her four-month-old baby to share the cabin. Two became four and my bed was right beside the bin where the nappies piled up over the journey. There was little to no sleep, so we'd arrived, dumped our bags at the hotel, and headed out to a bar with the others.

The next morning, we sat on the bed in our hotel room trying to find the energy to leave, feeling simultaneously lazy and guilty about being in the Chinese capital and being too ill to explore, what a waste! The floor-to-ceiling window looked out over a gap between two buildings as young cadets practised a synchronised routine with sticks. We'd missed the organised group tour to the Forbidden City but had a vague idea we could make our way there alone.

An amiable chap approached, started walking alongside us, his hands hooked in the straps of his rucksack, an art student, he told us. Where are you from? Are you in Beijing for long? He said that his studio was nearby, that there was an exhibition, would we like to go?

We followed him down some side streets. There are lots of low buildings in Beijing, almost medieval, very charming.

His studio was in one of the low buildings; there were two guys working away with calligraphy brushes and black ink. It was a proper shop rather than a studio and it became clear that he wasn't really an artist – he disappeared off the scene

very quickly when we arrived. There were scrolls of various sizes hanging on the walls. The guys spoke fluent English. Where are you from? Are you in Beijing for long?

One guy began to draw symbols on heavy cream paper and sliced through red silk.

'Your Chinese is so good,' the artist said to my partner as he attempted a few words.

Somehow we were buying two of the scrolls and then the price we'd agreed doubled, then trebled, but we were too hungover to argue.

The symbols represent good luck and love, he told us.

We'd spent the previous night and early hours singing karaoke and drinking brandy – there are lots of blurred and useless photos that could be anywhere. So the scrolls ground us in a time and a place.

We left the studio, walked down the street a bit, and then a young woman approached my partner.

She gave him her business card, 'For the next time you're in Beijing.'

'Excuse me?' I asked her.

She didn't acknowledge my existence.

'The next time you're in Beijing, call me.'

Good luck and love. From his point of view, the scrolls were working right away.

We walked for a while along the street in silence until one of us said,

Two pigeons
Two balloons
Big windows saw us coming

The scrolls are both a talisman and a testimony to our willingness to participate in the transactional role play. It was like we were watching ourselves. The scrolls are a reminder of a state of mind. They're on the wall because I think they kind of have to be. We were duped and paid over the odds for them

so they're also a symbol of our failure to haggle or bargain
that day. I grew up in a haggling household. My dad will
haggle and bargain everywhere, nowhere is off-limits;
he haggled over a camera in Boots once and got money off.
I can't haggle at all, not remotely, totally useless.

We look at the scrolls sometimes and say,

Two pigeons

Two balloons

Your Chinese is so good

ROTHKO EGGS
Keith Ridgway

She told him about her dad and the eggs.

– I made my dad scrambled eggs one morning yeah? When I was staying in his place for a weekend. He sleeps late you know. And I made him breakfast when he got up, you know – good little girl. And it was like, scrambled eggs on toast, and some bacon and a tomato. Stuff like that. And a pot of tea. Glass of orange juice. All posh. And he really liked it. And then he was trying to show off that he knew about art – he's always doing this – and he splatters ketchup all over the scrambled eggs and he said, *Rothko eggs*. Pointing at the eggs yeah? *Rothko eggs*. I didn't know what he was on about. *They look like a Rothko painting*, he said, all pleased with himself. And then I realised that he'd gotten Rothko mixed up with Pollock!

She laughed.

Stuart smiled.

– So now he still calls scrambled eggs *Rothko eggs*. I never corrected him. He hasn't realised yet. So he's always asking for *Rothko eggs*. I bet he does it at work and everything. Trying to show off how cultured he is. Down the police station, you know? Pretending he knows his art. *Had some great Rothko eggs this morning.* And no one has a clue what he's on about. It's so funny.

And she laughed, to show how funny it was.

Mauricio Alejo, *Ham*, 2014. Colour negative, 10.15 × 12.5 cm. Courtesy of the artist.

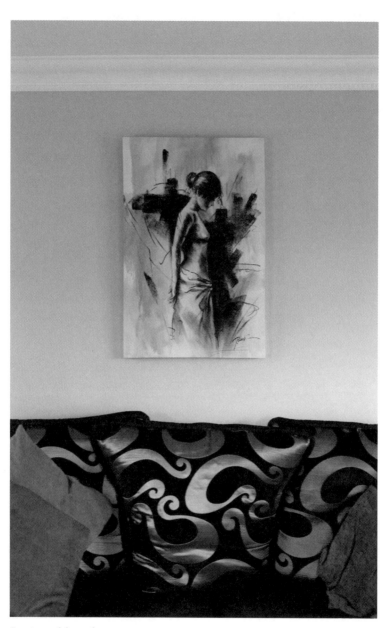

Courtesy of the author

THE LADY IN MY LIVING ROOM
Joseph Scott

In my living room is a naked lady. She's placed behind my
sofa. A towel covers her lower body, while the upper half is
open for the world to see. She stands in a side profile, with her
head slightly looking down. Her hair is tied in a bun, but
loose strands dangle in front of her face. Everything is black
and white. Around the woman is some kind of artistic design.
Whatever it is, you can see the brush strokes on the canvas.
Some thick, some thin, but all black. The woman herself is
grey, but the shadows on her skin are a darker shade. Shadows
conceal the details on her face, but if you look closely, you
can still see her long eyelashes and thin lips. At the bottom
right-hand side is a name that I struggle to read. I believe it
says Rodery.

I wanted to be the next Martin Scorsese. Me and my little
Canon DSLR. A-level Moving Image required me to make a
short film. It was heavily inspired by *Ferris Bueller's Day Off*,
and by heavily inspired, I mean, I basically copied scenes
from the film and added a Northern Irish twist.

I begged my mate to be the starring role, and one day after
school while my ma was at work, we got to filming.

We shot it in the living room. I got a chair from the kitchen
and placed it in the middle of the room. My mate sat in it
while I tinkered with my tripod. A terribly broken piece of
equipment that was held together by Sellotape and luck.
No matter what I did, when I placed my camera on the tripod
it made my footage lopsided. My mate had to deliver his
lines directly to the camera. Breaking the fourth wall, like
in the film.

I had my eyes on my living room floor, making sure
that the tripod wasn't scraping my ma's dirt brown timber
flooring. If I got a scrape on the floor, I would've been killed.

I closed one of my eyes and with the other, I looked through the viewfinder. I could see my mate sitting on the chair, his head turned to the left. His eyes wide, his mouth slightly opened. The naked lady caught his eye.

'Gary?' I said.

Nothing.

'Gary?'

'Wa?'

'You ready?'

He turned towards the camera. His face turned red, and a wee smile appeared. 'Aye,' he said.

We shot other scenes in my living room throughout the week. Then, as the months went on, I started editing the film together to show to Mrs Thompson.

In the background of some shots, the naked lady was visible. The lads in my class asked questions, and so did Mrs Thompson. In fact, the naked lady caused a bit of controversy due to her nudeness. It was even being discussed whether the film was eligible to be submitted because of her. Of course, the lads just found this funny, and Mrs Thompson asked if I could blur the nipple, but as time went on, the film was deemed acceptable. I was kind of proud of the fact that my first ever film was considered to be some kind of saucy rated-18 movie. It was the talk of the school.

As I got older, many things around the house changed. Wallpapers, painted walls, the layout of furniture, but the naked lady remained. I finally asked my ma one day, 'What's the craic with this paintin'?'

It was around midnight, my ma was drinking some wine, and her answer was something I wasn't expecting.

You see, my ma had an ex-boyfriend who was controlling at times. I was younger when he was about, so I never really noticed. What I do remember about him was the smell of his feet. The man's black socks reeked. One time, I went into the bathroom to find the bath filled with water and one of his

black socks just sitting in the water, soaking it up. Never asked him what that was about. I didn't like him too much if I'm being honest. His voice would wake me up as he spoke on the phone. Whoever he was on the phone with, he kept repeating himself with this deep, loud 'aye.'

My ma doesn't want many things. All she wants is for her home to be 100 percent hers. She loves to design and decorate. It feels like she changes up the living room every month. The ex-boyfriend must've had his own ideas of what he wanted done with our living room, but my ma wasn't having it.

My ma and granny headed on down to Select and came across the naked lady. Later that day they put her up on the wall and sat around drinking their tea, waiting for the ex-boyfriend to come home.

When my ma told me this I put my hands behind my back and stared at the painting as if I was an art dealer. My ma got up from the sofa and stared at it too.

'She looks sad,' my ma said.

'Yeah, a bit. Is that what it reminds you of?'

'A bit.'

'Why do you keep it then?'

'Don't know.'

The naked lady represents more than she knows. Me and my ma look at the painting and get two different emotions, two different memories. She said she doesn't know why it's still up, and neither do I, but I do know if we decided to take it down tomorrow, if we got a new painting, it would feel like a betrayal. Throughout the years, without knowing it, the naked lady somehow integrated herself onto our grey-coloured living-room walls. It became one, not just with the living room, but with our home.

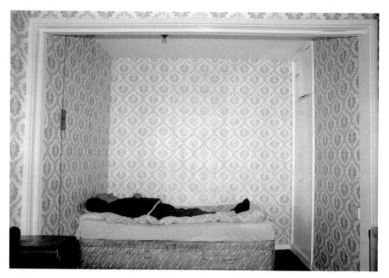

Richard Billingham, *Untitled*, 1995. C-print. © Richard Billingham. Courtesy of the Anthony Reynolds Gallery, London.

ART
Joanna Walsh

You can hear the doves all the time in our garden, under the sycamore. I don't like sycamores. They're ubiquitous. There must be better trees. Sycamores can't be right. In town there are chestnuts and also those trees with small spiky balls on them that grow soft and green in pairs like hair bobbles. The doves in our garden say something else no they say somewhere else from their tall perspective looking down on lawns mowed with stripes, somewhere nature isn't the same kind we have round here.

In Rosemary's mother's house Rosemary's mirror. A dressing-table set. A kidney. That sort with a skirt, a ballet skirt round it. The mirror gilt and white, white with the gilt knocked off. Her dressing table white, old white a bit yellow like teeth the skirt around it lilac underneath it's only chipboard.

If you lie under it you can see.

We are outside both in skirts no tights in our garden under the sycamores, the cold grass folded under Rosemary's knees too.

Rosemary says to me, *what's your ideal underwear?*

I say, *white, really plain, cotton, but white all the time. Not the kind that goes grey.*

This is not what I am wearing.

She says, *colours. I like to mix and match.* She says, *what's your ideal hairstyle.* I say, *I don't know just so it always looks good and I don't have to do much with it.*

In Rosemary's mother's house downstairs a doll, I mean a full-grown doll a mannequin that's what they call them, no arms no legs no wig, her lower half draped in a skirt her breasts bare. A green hat with a feather, a red Venetian mask. Tho their house is just like all the others I'd never been anywhere like it before.

Who are these grown-ups allowed to pretend?

When we got up our knees and lower thighs were the colour of boiled ham and had the shapes of many crossing grass blades printed on.

Rosemary's mother's sofa is flower print. It is saggy with use. It was cream but it isn't now. Rosemary's mother doesn't care. She doesn't care and it doesn't matter. This is amazing! That we can sit on the sofa and it doesn't matter and drink tea and eat biscuits and it doesn't matter. Under my legs I can feel the strings from her sofa where it's worn through at the edge on the back of my knees.

In my house are two paintings. Or they are not paintings, they're pictures of paintings – flat, no texture. They are both in narrow gilt frames with the gold rubbing off like Rosemary's dressing-table mirror. They have glass on the front. One has a title underneath it is called rain steam and speed. It's a brown mess. I don't know what it's of. I try to put the words next to something: nothing fits. The other is a picture of a girl sitting looking at something, her face lit from the front. She's wearing something big and mushy on her head. It's blue perhaps some kind of hat. It's at the back of her head which looks uncomfortable how does she keep it on I can't see the details. There are ugly yellow lights in her hair the same colour as the ugly yellow of the flowers in her hand. By ugly yellow I mean a smeary dirty yellow. You don't see flowers that colour ever. Why is she holding a bunch of flowers sitting down? There is something green and curved behind her a wall I don't know why it's curved like that and the edge of it is gilt curly like the frame. Beyond it people very blurry like looking through glass. She's looking out at them I don't know why or why they are there all together. They seem to be moving about but not enough getting up and sitting down but I can't see on what. There are red and yellow marks on them that look like her flowers. Her mouth is open like she wants to say something but stops. She looks anxious even afraid. This is wrong I think. People don't

have that look in paintings. Anger maybe or hate, big emotions, but not that no. I don't know what to call it. It is a moving toward something.

The mugs in Rosemary's mother's house have chips. Nobody minds. People can live like this. They can live like this and still have paintings on the wall. I thought you had to have the furniture before you got the paintings, that you only got real paintings when everything else is nice. That's how it works for everyone else. Rosemary's mother has real paintings. They look imperfect you can see little marks on them and brushstrokes. There's a drawing and the corner's torn off and there it is still framed.

My parents never talk about the pictures. I don't know where they got them from, or why. They're art, so they must be beautiful. I respect them because of that.

Before I envied the people with those houses that look just like they're meant to: the fences white and the woodwork white even if that way of life was peeling and the window where the telephone's inside just where it's meant to be so you can see someone sitting there through the wavy glass talking on the telephone just like they should be and carpets just like they should be in the hall and all the way up the stairs.

Now I envy Rosemary. But I don't know why.

My parents' two pictures are exactly the same size.

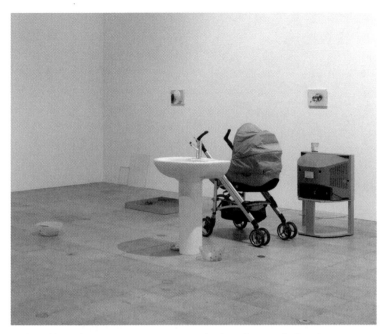

Cathy Wilkes, *She's Pregnant Again*, 2005. Mixed-media. Installation view,
How to Improve the World: British Art 1946-2006, 2006, Hayward Gallery, London.
Courtesy of the artist. Photo: Marcus Leith.

PERCEPTION OF AN OBJECT COSTS
Emily Dickinson

Perception of an object costs
Precise the Object's loss –
Perception in itself a Gain
Replying to its Price –

The Object Absolute – is nought –
Perception sets it fair
And then upbraids a Perfectness
That situates so far –

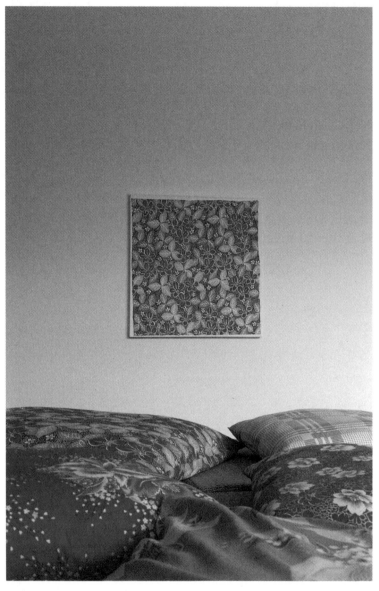

Michael Lin, *Pillow #5*, installation view, *Complementary*, 1998, Dimension Endowment of Art, Taipei, Taiwan. Oil on canvas, 85 × 85 cm. Courtesy of the artist.

THE ARCHITECT AND THE HOUSEWIFE
Frances Stark

The following essay first appeared in a catalogue for the 1998 exhibition Complementary *by the Taiwanese artist Michael Lin, which sought to bring 'into dialogue' the public space of the exhibition and the private space of the domestic interior. The show consisted of colourful house pillows scattered on a large plinth, while on the walls surrounding it were hung oil paintings of the patterns on these pillows. Frances Stark included the text in a monograph of the same title published by Book Works the following year.*

I have had complaints about my couch, which bisects my living room diagonally, orienting the viewer towards a rather delightful view overlooking the city and its backdrop of hills, behind which the sun can be seen disappearing nightly. Although not lacking a handful of admirers, the couch seems to provide inadequate comfort to most visitors, either they say so directly, or more often express their discomfort silently by choosing to make themselves comfortable at the kitchen table in the adjoining room, from which you only have a view of purple and pink flowers. The couch is a Danish modern design, smaller than your average couch, with quite thin square cushions, extremely attractive actually. However, I don't think the design is the problem. The problem, rather, lies in the fact that directly behind the couch, meaning directly behind the head of anyone sitting on the couch, is my desk. It's technically just a table, a long one, slightly longer than the couch and only an inch or so taller than the top of the couch. The large rectangular surface of the desk is covered in that dark chocolatey-brown, fake wood veneer. Its edges are curved, lined with dark brown plastic trim about an inch thick. Its base, collapsible if necessary, is made of thin cheap

metal, painted, of course, dark brown. Usually the entire surface of the desk is covered – my computer, loose papers, books, and stacks of this and that. So, not only is it just a desk behind the seated person's head, but also an unruly mess made up of stacks of loose papers that can and do easily stray from the boundary of the table-desk towards the head and shoulders of a seated guest. It's a mess because it lacks any of the simple and ingenious design conveniences which might usually be incorporated into a well-made desk in order to keep papers and various other desk-dwelling items under control. I failed to mention that the table/desk lies flush with the back of the couch diagonally bisecting my living room in order to leave all possible wall space open. I use the desk for writing andthe walls for making drawings, which I may as well tell you, are made up of writing. So you see this curious arrangement (of my couch and my desk, not my writing and my writing-drawing) is predicated on the fact that not only is my living room my living room but my living room also serves as my studio.

The dilemma of having a couch in my studio is perhaps an interesting one. If I can't get sufficiently engaged in a book, or making a drawing I might end up staring into space. You can't stare into space forever, so I might start to look around and begin thinking to myself, this house is too messy or not nice looking enough or those drawers should be cleaned out or perhaps if I got a different piece of furniture for over there I could rearrange this here and my life would run more smoothly. I am sparing you the details of my toil which aspires to productivity, suffice it to say it is not hard not to experience, on a regular basis, the loneliness, the anxiety, the constant urge to redecorate I imagine a housewife might feel.

The possibility of becoming an active consumer can drive me out of the house – once entering Ikea, or even Office Depot – wherever – the world opens up in terms of what me

and my home, office, studio can become. On two separate occasions I bought a pillow from a chain store called The Pottery Barn. Both times I resented the homogeny of the store, but both times I thought to myself, 'My head deserves the luxury this pillow has to offer.' The first pillow purchase actually can be broken down into two parts. Part one is I simply bought a pillow without a case at Ikea, the first throw-pillow I ever bought in my life, by the way. In the do-it-yourself spirit of Ikea,[1] I planned to sew my own case out of something special. I don't really sew, but it seemed simple enough. Several weeks passed without me sewing a case. One day my father and baby brother drove into town. We planned to drive to the museum where one of my drawings happened to be hanging in an exhibition. We got in the car to go there but first we needed to eat. In our search for a meal we could all agree on we got completely off track and far from the museum. By the time we finished eating it was quite late and we were running out of time, and because adult things are harder to do with a six-year-old in tow, we ended up at the mall across the street instead of the museum. That is where the first shop that sucked me in spat me back out again with a baby blue angora pillow case. That was part two of pillow purchase number one. Pillow purchase number two is like this. I was feeling heartbroken and unable to work. My friend Laura, a painter, learned of my useless condition and decided I needed escape. She drove me to a heavily populated shopping area. We walked into a series of stores that sold housewares and took turns interpreting the merchandise. We ended up at The Pottery Barn and she bought a variety of

1 Possibly traceable back to the Larsson's, a big influence in Swedish design movements. See 'The Ideal Swedish Home: Carl Larsson's Lilla Hyttns' by Michelle Facos in *Not at Home: The Suppression of Domesticity in Modern Art and Architecture*, ed. Christopher Reed (London: Thames & Hudson, 1996).

blue floral pillows in different sizes whereas I selected a large summery two-tone green silk. But this second trip to The Pottery Barn, with another woman artist instead of my father, coincided with the moment at which I recognised there was a novice homemaker-cum-consumer in me that was eager to get out and find a rug, an inoffensively scented candle, or a pillow at precisely the time I should be sitting at the chocolatey fake wood table pushing through a difficult piece of work.

The kind of anxiety associated with working alone in a domestic environment is precisely what brought the housewife to mind. I have sometimes found myself envying a male friend, here or there, who happened to be engaged in large-scale art projects, out in the open air, or inside institutions with many people running around to ensure an imminent production. Was I not unlike a housewife, toiling within the confines of my home and serving as both hostess and docent of my tiny quarters? Were these men not unlike architects in that they were constantly carrying out plans – giving instructions, making constructions?

The impetus behind these categorisations had a little bit to do with the idea of couples. I knew of some couples in the art world where the female part of the couple happened to be engaged in works that were more studio-oriented, in that they were either paintings or some other type of practice which typically has to be carried out alone in the studio whereas their partners were involved in projects that were sculpture-oriented and employed many more people in their realisation. I thought about the studio works and how their viewing demanded a certain kind of intimacy and physical proximity to the viewer and how the men were making work that – although in some cases dealing explicitly with issues of domesticity – surrounded a viewer, was public, or involved some kind of environment or activity that accommodated more people at one time than could stand in front of a painting or read a tiny text in a drawing on the wall. It wasn't

that the females weren't getting as much attention as the men, it was just a difference which made me consider whether or not I was somehow involved in an extremely conservative, not to mention lonely, practice. The painter Laura and I decided to pursue this extreme binary of the architect and the housewife as a way of reflecting on and examining current art practices around us. This construction, as simplistic and reductive as it might sound, started to prove effective. In fact more than just elucidating differences in interior versus exterior sites of production, we began to consider whether 'interiority' and 'exteriority' were types of meaning-production as well, interiority evoking more of a Romantic tradition and exteriority being perhaps more in line with the avant-garde. Maybe, maybe not. I can imagine *The Architect & The Housewife* as a heading over almost any discussion regarding post-studio art practices which focus on decorative and design issues, whether in a public or private space. I can imagine its applicability to those works which seek to examine or at least evoke modernism's failures or successes, its utopian designs-for-living, or to those works which rely heavily on a public setting or large quantities of institutional commerce to bring the final product, object, and/or site into being, and last but not least those practices which seemingly overlook their complex reliance on the architecture and structure of the 'art world', still insisting that the hand-made portable object is capable of producing meaning within its limited frame.

But first, back to basics. I presume a housewife is someone who will stay and maintain the home, decorate, arrange, rearrange, prepare, wash, put things away, bring them out again – the house not being a site of accumulating production but a site of a series of simultaneous productions which bear no evidence of productivity – save for the fact that the home isn't falling apart. A supposedly good housewife maintains a busy environment which should appear as if

nothing has ever happened. Nothing is being built *per se*. The architect, on the other hand, solves problems the public doesn't think about but which affect their consciousness of the environment, from things as essential as material, lighting, and scale to more socially articulated needs like safety, cost, codes, et cetera.

The exteriority I have so far mentally ascribed to 'the architect' has to do with elaborate extensions, disruptions, and transformations into and of material reality. And, by extension, the act of writing, with a special emphasis on fiction, seems to demand very little in terms of outside space – no commerce, a budget of mostly just living expenses, minimal materials – not much of a production. The production doesn't extend into or employ much of the exterior environment. Publication and distribution are different matters entirely since the formal completion of the work of fiction does not depend on the realisation of either. However in the case of this writing here I wanted to break out of the confines of a personal interior and experience Taiwan. Flying halfway around the world to look at an exhibition and make a short piece of writing, for which I would receive a small payment, is a way for me, personally, to upset my imaginary position in my binary configuration. Recall the famous piece of writing by Virginia Woolf, *A Room of One's Own*. This text, written in 1928, was meant to address the slippery topic of women and fiction. In it she writes: 'A woman must have money and a room of her own if she is to write fiction'. Isn't she suggesting that a main prerequisite to productivity is privacy? A woman, if she is occupying and/or upkeeping everyone else's rooms is going to have a difficult time getting any work done. Sure, she can enjoy many other 'rooms', consuming culture with the best of men, but when it comes to producing culture it might not only be a question of where she will do it but also a question of where you will consume it. Think of literature

as an interior event, the mind or imagination being the place where the text unfolds. And consider the interior of the head – the particular bodily limits of your own perception and yet the seeming limitlessness of thought.

Now think of the interior of a home, to which a housewife has historically been expected to attend. Traditionally it is meant to provide her partner with a restorative and pleasant atmosphere so that he can continue his hard work in the public sector. Here I am talking about European bourgeois society around the turn of the century at which time something called 'neurasthenia' was a common form of nervous exhaustion thought to be brought about by excessive use of the brain.[2] Businessmen were advised to temper their neurasthenia by going home to a completely soothing environment. Patterns found in decorative art objects which adorned the home were meant to offer repose in the domestic setting.

> The function of décor is not to arouse particular emotions, but to give the milieu a character in accord with the man who must live there, without compelling his thoughts to focus on the image of a concrete reality, without forcing them to be objective when the hour of subjective refuge awaits him.[3]

Consider now the boundaries of the studio – not a home and not just a room. I came across a particularly striking phrase of Daniel Buren's in an essay published in *October* magazine

2 This and the following quote come from the essay 'Hi Honey, I'm Home: Weary (Neurasthenic) Businessmen and the Formulation of a Serenely Modern Aesthetic' by Joyce Henri Robinson. This essay can be found in the book *Not at Home*.

3 From an article entitled 'The Interior' from the journal *L'Art décoratif*, 1901.

called 'The Function of the Studio'. Here is Buren's phrase, his heading: 'the unspeakable compromise of the portable work of art'. The compromise Buren finds unacceptable is that if a work is produced in a studio it is automatically wedded to that space, it somehow lives perfectly in that space, yet its portability is some kind of breech in integrity, meaning that it compromises itself by having to leave its home and go to a supposedly neutral gallery or museum space. This is at once declaring that a work should completely take into account that the museum or gallery space is nowhere near neutral and that somehow if one denies the work's relation to its space, one is on some level choosing to ignore the values the museum/gallery architecture ascribes to the work and the work itself is simply a piece of merchandise that shuttles easily from the studio into the marketplace. By the time I came across this I had already been ruminating on Michael's pillows. It is interesting how the paintings of the pillows conjure up both the portability of painting as a practice, as well as the portability of the pillows themselves, a major contribution to their use value. Also *Complementary* exhibits a self-consciousness of its status as exhibition. Not only does its intervention into the architecture offer a better view of outside to its viewers, it allows for more natural light to be shed onto the work, and that view is made available to you now seeing as how the show documented itself. O.K., so I have just put the ideology of institutional critique into a convenient nutshell but let's put scholarship aside for the sake of letting Buren's 'unspeakable compromise' resonate poetically under my compromising heading – granted it's an extremely subtle poetic.

There are a few ways to read the word 'compromise', one being more drastic than the other. The drastic way, which is surely what he meant, is 'to make liable to suspicion, danger or disrepute'. But I also think of a compromise as simply a settling of differences – for instance, something a couple must

do to stay a couple. I have learned that the fabric used and reproduced in *Complementary* is a fabric associated with the wedding night. So, as it turns out, there are couples all over the place here and with a title of a show that means 'offsetting mutual lacks' you can bet there's no way to have a hermetically sealed art discussion, there have to be men, women, unhappiness, happiness, weddings, divorces, and sex. I mean I won't explicitly discuss these things I just don't want you to forget about the fact that a home is usually designed for a family which starts with a couple, which is usually made up of two people who at some time in their compromising and complementary relationship have rolled around naked together on some pillows or some equivalent thereof. That reminds me of something. Adolf Loos, the Austrian architect, famous for his manifesto against decor, once wrote, 'All art is erotic.' He didn't mean it as a compliment. Sure this is seriously taken out of context, but wait.

The architect R. M. Schindler, also Austrian, designed his own residence in Los Angeles to be occupied by two couples. He seemed to be aspiring to a different kind of domesticity. Each couple would have their own bedroom and places in the house in which they did their work and studies, with several common indoor/outdoor living areas. The house is too complicated to describe here in detail but the pertinent part for our story is that the two couples did not end up occupying the place harmoniously and it ended up just being the home of Schindler and his wife, Pauline. Finally that couple, too, disintegrated. They divided the house and lived there, separately, together. His wife began to hang wallpaper and install carpeting, decorating her part of the house exactly the way she wanted, and here I might add that pink was her favourite colour. Her husband would draft her letters which went something along the lines of 'I am sure you are familiar with the reasoning for my choice of materials and that what you have done is completely incongruent with my design

and destroys the integrity of the structure', something along those lines, 'signed, R. M. Schindler, Architect'. So much for compromise.

Famous architects throughout history have also been known to design chairs. Adolf Loos, Le Corbusier, Mies van der Rohe, Eero Saarinen, Frank Gehry, and so on, even Schindler. The specificity of the challenge lies in the intimacy with which a body is to interact with a chair, an intimacy far greater and literally more pressing than between a body and a building. Here there is a direct correlation with contemporary artists' desire to address private individual comfort from the standpoint of an extremely public and social-oriented tradition. Domesticity, interior design, and private vs. public space surface as issues in the works of many young contemporary, internationally renowned artists (which might be squeezed into the architect category), artists whose practices are in line with Daniel Buren's oppositional ideology. In a lot of instances the work directly involves seating: the upholstering of chairs, a pier on which to venture out, buy a pack of cigarettes, smoke, and enjoy the view, a private island, the transformation of a public Donald Judd sculpture into a bench at which to sit with friends, drink alcohol, and listen to music, a building turned into a lamp with a rug laid out in front of it. Some of these projects were taken from *The Sculpture Projects in Münster* (1997), which culminated in a five-hundred-and-forty-page catalogue of the exhibition. Interestingly enough, Daniel Buren not only participated in the project but contributed a manifesto-like text to the catalogue. I was reclining on a rug under a lamp next to a stack of art catalogues [...] leafing through this gigantic catalogue thinking about how despite the fact that Buren's critique of the portable object is now pretty much the dominant ideology, there surely is no shortage of the most portable object of all time, the book, and here I refer specifically to the art catalogue, which ensures that a

work - no matter how problematic or ephemeral, no matter how casual or whimsical - remains a work of art, and a portable one at that.

Another book I happened to find [...], aside from the Oscar Wilde one, was *The Sense of Order: A Study in the Psychology of Decorative Art* by E. H. Gombrich. [...] I couldn't believe its pertinence. Just that day I had come so close to buying a different book by Gombrich, my first one by the way, as with the Ikea throw pillow. [...] And now here was Gombrich again, this time tempting me to just copy half of his book by hand and put it in the catalogue instead of my own writing. And not only that. Right at a critical point where designers were considering themselves equals with painters, he quotes *The Critic as Artist* [...]:

> The art that is frankly decorative is the art to live with. It is, for all visible arts, the one art that creates in us both mood and temperament. Mere colour, unspoiled by meaning, and unallied with definite form, can speak to the soul in a thousand different ways. The harmony that resides in the delicate proportions of lines and masses becomes mirrored in the mind. The repetitions of patterns give us rest.

Now bear with me, I am about to put that Loos business about all art being erotic into context for you. According to Gombrich 'the emancipation of pattern design into a dependent art with growing pretensions foreshadowed the divorce between decoration and functional fitness'. He quotes Loos, who vehemently requests the divorce, from his 1908 essay 'Ornament und Verbrechen'. But before that he briefly points out that as early as 1892 the American architect, Louis Sullivan, had written: 'It would be greatly for our aesthetic good if we should refrain entirely from the use of ornament for a period of years in order that our thoughts

might concentrate acutely upon the production of buildings well formed and comely in the nude.' Here it sounds like Sullivan is only calling for a friendly separation instead of a divorce. And I know with Sullivan they get back together, and I know this because I know Sullivan was obsessed with decoration until his very old age because in fact I happen to have a tattoo of one of the drawings he made after he had stopped making buildings. So, you can imagine my excitement when I first read those few sentences heretofore left out from in front of 'All art is erotic': 'The man of this century who tattoos himself is a criminal or a degenerate ... The urge to ornament one's face and everything within reach is the very origin of the visual arts. It is the babbling of painting'. According to Gombrich abstraction in painting didn't occur until after this complicated and competitive intermingling of decorative art with high art. And speaking of babbling, I have babbled on long enough but I'd like to bring this full circle if I can, and bring your attention now to an image of a perfect couple, a perfect marriage, where the gesture of placing a pillow in just the right spot has made history.

[A photograph of Charles and Ray Eames in their living room] shows three pillows of the same size placed on top of each other, on a rug, on the floor, offering contrasts in color and tone. At other times, more pillows were used and the grouping was placed slightly differently on the rug and in relation to the other objects. On the Sofa Compact in the late 1960s and for much of the 1970s, two patchwork pillows complemented each other and contrasted with a larger striped one.[4]

4 Pat Kirkham, *Charles and Ray Eames: Designers of the Twentieth Century* (Cambridge, MA: MIT Press, 1995), 188-89.

54

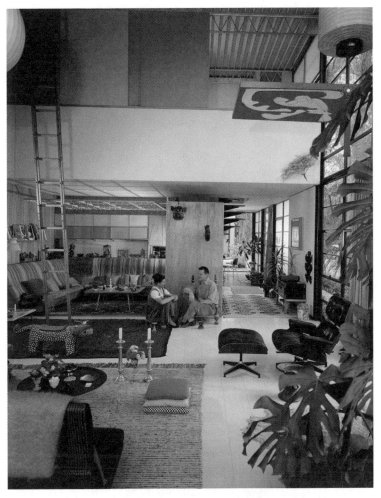

Charles and Ray Eames in their living room, Pacific Palisades, Los Angeles, CA, 1958. Photo: Julius Shulman. © J. Paul Getty Trust. Getty Research Institute, Los Angeles (2004.R.10).

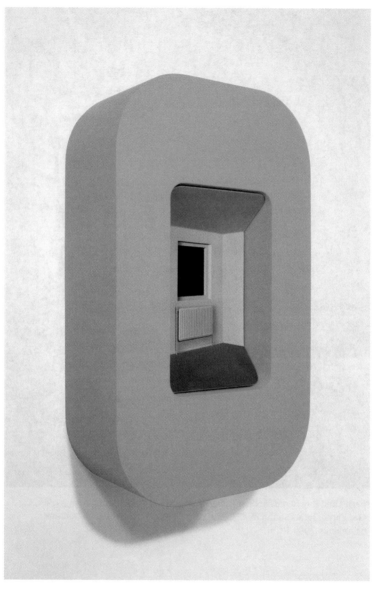

Maurice van Tellingen, *Utopia Ii, Lone Star*, 2016. MDF, glass, metal, alkyd paint, LED lights, 53 × 86 × 22 cm. Courtesy of the artist.

IN THE KITCHEN
Wendy Erskine

Do not bother today with that beautiful museum and its
austere angles, its epoxy grey floor. Forego, if you can, the
white cube. Come instead to a place where a tub of yoghurt
sits next to Flash all-purpose cleaner. On top of a microwave
there is an orchid plant and a set of Russian dolls. There
are tea towels, a box of paper for recycling, piles of bills.
The clutter some might consider unconducive to a serious
consideration of art. But let's try anyway.

Above the bin and in close proximity to both the handle
of a brush and a calendar in which no one ever writes dates
is an unframed A2 print of *Het Straatje* (*The Little Street*)
by Vermeer. It's a contemporary golden age street scene of
seventeenth-century Delft. Against a cloudy sky is a red brick
house, a street, and a passageway. The houses are rendered
in meticulous detail, their cracks and peeling paint. The
gutter that runs the length of the passageway and along the
street is predictably grimy, the brick discoloured. Coloured
in the same hues as their environment – brown, black, beige –
are four people. We cannot see their faces. One is sitting,
sewing in a doorway. Another woman down the passageway
holds what looks like a broom. The workers frame two
younger people, possibly children, a boy and a girl, who play
a game on the ground. From the curve of their shoulders, and
the unhurried way the people go about their business, I infer
a degree of content. But I do not know. Two of the people
have their backs to me. They are essentially unknowable. This
is an anti-showboat painting where nothing is remarkable.
People are placed against a material background that is
scuffed. But it is a brilliant painting, presenting ordinary lives
defined by place and circumstance. Yet what are 'ordinary
lives' anyway? The painting allows them their privacy.

Now, if we negotiate the table with its dead sunflowers in a vase and packet of rolling tobacco, its couple of mugs with the dregs of old coffee, we come to a print-out pinned to the wall of 'R69-26' by Jan Schoonhoven. This piece from 1969 is acrylic paint on cardboard and paper on plywood. It consists of geometric squares that have creases of eight triangles within them. It is white. The only colour, as such, is the grey of the shadows cast by the edges of the relief. I've heard it said on occasion that Protestantism doesn't have a strong visual culture, but that maybe presumes that visual culture is defined by, say, the baroque, the ornamental, by visual symbol. In *Whitewash and the New Aesthetics of the Protestant Reformation*, for example, Victoria George challenges the view that the practice of whitewashing churches and their frescoes during the Reformation was simply covering up stuff with a cheap lick of paint. There was also beauty in it. Zwingli declared that 'in Zurich we have churches which are positively luminous; the walls are beautifully white'. White, a Spartan aesthetic, can be loaded with significance. In writing, what is being said, or at least implied in the white, can be as significant as the words themselves. White as a colour is complex and I like being reminded of that by 'R69-26'.

There is a Dutch tradition of miniature houses. Women of the affluent Dutch merchant class displayed dolls' houses that could often cost as much as an actual canal house. Full of objects made to scale, they were indexes of wealth – the female counterpart to a man's collection cabinet full of expensive curios maybe. Have a look at this picture, next to a dentist's appointment reminder Blu-Tacked to the wall. Have a look at this photo of the Maurice van Tellingen 3-D piece called *Utopia Ii, Lone Star*. In some ways you could say that he belongs loosely to that miniature tradition since what he produces are small 3-D versions of parts of houses: doors, windows, a washing machine in a kitchen, a windowsill and a net curtain. There are rarely ever people. If they are there, it's

no more than a shadowy presence – a shape behind curtains, a misty outline in a shower. Most importantly, the scenes – unlike the opulence indicators of the miniature houses – are resolutely quotidian and quite austere. The aesthetic is as much a house in a '70s development on the outskirts of Belfast as it is anything particularly Dutch. My photo of the piece shows a plastic box with bevelled corners, reminiscent of the interior fittings of an aeroplane. In the centre there is a construction of the corner of a room: brown floor, white walls, grey ceiling. There is a small white radiator and above that a window, almost square. The darkness presses against the window, a dense black. Look very carefully and there is a constellation of stars but they are difficult to discern. In some ways it is not unlike the Schoonhoven piece in the way that the whiteness of radiator, wall, windowsill, and frames are all diverse, with light and shade being considered in a painterly way. But the overall effect is this: the incredibly, almost perversely mundane, placed in a stripped-down and unfamiliar context, has a poetic charge. That radiator, it's touching. That windowsill, it has such poignancy. It's hard not to supply the stories the piece suggests, stories of shelter and heat, the blackness outside, the small hope of the stars.

There is a shelf above a defunct old Rayburn cooker that we use to store crisps. On the shelf there is an oval plate and a golden inflatable 1 and 8, left over from a birthday. Above this there is a tiny painting in a Neo-expressionist style, no bigger than a postcard. It is of a man of indeterminate age, against a background of what? Black trees? The silhouettes of houses? He looks at the viewer, his head cocked to one side. It's not confrontational but neither is it diffident. The painting is by the artist Johannes van Vugt. In 2014 we had chanced upon an exhibition of his work in a gallery in the Jordaan. The exhibition was called *Close to the Edge*. It featured mainly children, often isolated. It made a massive impression on us, but we were unable to buy even a catalogue because it was its

last day. It is often difficult to assess why certain pieces of art, be they songs, books, or paintings, have such an effect. Quite often the situational element is significant. For whatever reason we both thought about the exhibition even after we had long returned to our own house. I wrote to Johannes van Vugt to ask if he had for sale even a very small painting that I could buy for my husband for Christmas. In reply he said that another person had already contacted him with a very similar request. Of course, it was my husband. And so, we clubbed together to buy a joint present to ourselves in the form of the little picture above the cooker.

But move away from that cooker. Turn round to face the bookshelf. Pinned to the wall with a piece of Blu-Tack is the picture called *Mother Lacing Her Bodice beside a Cradle* by Peter de Hooch from around 1661. It is one of a number of genre paintings that feature unsentimental, interior scenes of mothers and their children. A woman, with her bodice half-unlaced, has finished feeding her child who lies in a wicker cradle. At her other side is a fairly nonchalant dog. Through a doorway to the right we see another person – a child – in another room, who looks through a further open door that is full of light. This use of doors to open up other vistas within the painting, a technique known as *doorkijkje*, is fairly common in paintings of the time. At times when it is taken to extremes it can almost approach mise en abyme. But its effect in this painting, as in others, is to suggest complexity. A scene can't be viewed in neat isolation. It is placed in relation to others, is contingent, is nuanced. The people in the world of the painting, although occupying the same space, are in different rooms. It suggests the physical closeness by ultimate unknowability of people. This is something I come back to again and again in my writing. But of course, these Dutch painters were doing exactly the same thing, almost four hundred years ago.

I remember someone saying that you never really understand the Middle Ages until you've been to Chartres

Cathedral. I kind of love absolutist, splashy statements like
that but I also realise they are ridiculous. Yet we hear them
a lot: the novel must do this, the novel must do that. Literary
fiction is this, modern art is that. More troublesome are
absolutist, essentialist statements regarding nations and art.
The Irish as a people with a strong oral tradition are drawn
to the short story form. What, en masse? Who exactly
constitutes the Irish people? And also, how useful is it ever
to think that artists of any kind, with widely differing views
and ways of working have anything in common by virtue of
the fact they live or lived in a particular country? That said,
in my kitchen in East Belfast there is a lot of Dutch art. This
could be because despite my misgivings there is something
about certain kinds of Dutch art that is particularly appealing
to my own sensibilities. Or it could just be that I happen to be
in Amsterdam reasonably frequently.

ALWAYS APPROACHING
David Hayden

*

There was nothing in the beginning, and too much ever after.
The walls of the house were empty, never quite white but
grey, or perhaps, in the memory, faintly yellow. The sea was
at the end of the road, and marine light, recalled in long
tenebrous durations, punctuated by brief hot reaches of salt
white, high blue light, lived all around and through. There
were no paintings or posters or photographs or ornaments.
No mirrors. No made form or image, no thing that could be
dwelled upon, or within, or mistaken as coming from life. No
thing from which to take sense or make story, from which to
depart into a world of feeling and connection. No diversion.
No companion. No consolation. All that had been, had been
broken, or sold, or lost; left behind in the other country.

On the coldest days of winter, a coal fire would be set,
and as the black burned orange, it made the first picture that
I knew, and from inside the calescent rocks, and out of the
wavering flames, with the cold at my back, my eyes and mind
would draw the comfort of warmth and of nameless shapes
and wordless stories.

On fireless days, a child might stare at patterns in the
carpet, or gather forms from the way the plain green curtains
fell in tubes and folds and pillars in the sea light. In bed after
dusk, there might be watchful spirits, trembling ghouls, or
nameless animals in flight that would not take me with them
on their journeys beyond the night. If I looked down there
was a pitch-dark sea, separating one brother from another.

In the day, sitting quiet and motionless on the settee,
causing and being no trouble, the child would look into one
blank wall or another and see what small part of everything
that he knew, knowing or feeling that it might go on forever

and mean nothing all the while. Or that the blankness might signify unending fear, always approaching. The empty wall might have been a looking glass, one that held the noise of the mind, silent behind a hard and spotted skin, one that would dwell inside and show the world its shadows, its nothingness, one that might look into itself and see howling.

But the walls were gelid and unmoving, damp and unmeaning, scanned over each day by starving eyes not knowing what they searched for, what this other hunger consisted of, what it yearned for.

Briefly, there were crayons and paper, and the waxy feel in my hand and the untutored motion that made marks that ran over marks and covered up the white blankness in an expanse of jagged colour that contained no animals or trees or people or buildings, but only what the walls spoke. These pages were not to be displayed but hidden away in a shoebox, with a found old coin and three marbles, that stayed in the dark, under the bed. And when I lay there at night, I could imagine underneath me the colours I had made.

**

There were no friends until the day in the secondary school playground when a boy, on whose lively group I was silently on the margins, approached me and asked if I wanted to come round to his house. Two evenings later, we walked towards the sea, away from the chemical factory where his father was a foreman and past the bakery where his mother worked.

In the hall I was asked to take off my shoes and I stood uncomprehending. I looked above me at a print in a plain brass frame on the wall at the foot of the stairs. The mother came out through the kitchen sunlight in an apron, rubbing her red hands on a blue tea towel.

'You alright, love?' she said, looking at my feet.

'Alright, mum,' the boy said, and kissed her cheek.

I bent and tugged loose my shoelaces.

'Welcome,' she said, and turned back from where she had come.

In the picture a boy in a blue silk suit, white lace collar, and silver-grey stockings, stood on a low stool, his hands behind his back, looking across a red-cloth-draped broad table, at three men, one leaning towards him questioningly. A fourth man took notes with a quill, a fifth stood tall in the shadows, a sixth was sprawled on a bench, staring exhaustedly at nothing. My sight flickered to a man in a breastplate and armour, carrying a spear, its long blade fringed with a red tassel, standing by a crying girl in a peach-coloured dress and cap, with his hand on her back. Two girls, or possibly women, in olive-green dresses stood anxiously in an open doorway, with more soldiers in the darkness behind them. Light, another person, hovered in the left and centre of the painting.

My new friend opened the door to the front room. I could see more framed pictures inside on the walls.

'You coming?' he said, and smiled.

I walk into a gallery room and, for the hundredth time, see a boy and a boyish girl, hand held in hand in promise, before a tree in lavish bloom. I open one of my books and see blind Orion searching for the rising sun.

I sit in my own front room. A picture on the wall, slightly crooked in its pale wooden frame, made by my son long ago of our first living room together, almost abstract with its strong black lines and wavering blocks of yellow, green, and red. I see a guitar. The picture is as present as I am. And behind the picture, the empty wall.

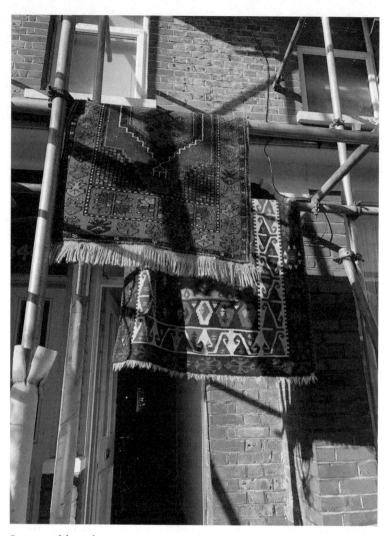

Courtesy of the author

THE RUG ON THE WALL
Latifa Akay

The rug has been a feature of my life for as long as I can remember. Small, but bold, it is detailed with geometric patterns and blocks of recurring colour, most prominently deep red, burnt orange, and olivey gold. During my childhood, the rug hung above the radiator in the living room of our family home in Belfast. As a child I assumed it must have had some importance to end up on the wall, but as far as I recall I never asked about it.

Many years later, the rug is now mine and lies on the wooden floor of my bedroom in North London. Sometimes I notice the colours greying with dust and, driven with guilt thinking of its more ornamental past, I carry it folded through the house and flap it about outside the backdoor, pulling strands of my own hair from its surface by hand. Even though the rug is decades old, once hoovered or shaken out, its colours are as vibrant as if it had been bought yesterday.

Recently I hung the rug, and another larger rug passed on from my parents, on my neighbour's scaffolding at the front of the house. I beat them first with a mop handle and then with the palms of my hands because the mop handle made no impact at all.

The sun was shining that day and the rugs looked particularly magnificent, swaying in the wind above the wheelie bins.

It is true and perhaps very basic that when I beat these rugs, I feel connected with the women on my father's side of the family. I imagine those women in floral skirts with elasticated waistbands, their headscarves tied under their chins, squinting, and flapping in small dust storms of their own making.

I realise in writing this that I know little about the women on my father's side of the family. Of the elders, I only have

names and snatched anecdotes. There is Necibe teyze and Ayşe teyze, my grandmother's sisters. My dad recounts how when he was a child, Ayşe teyze used to beg him to speak Turkish with her because she didn't speak it and wanted to learn, but he would continue speaking their mother tongue Zaza, because not many other relatives would speak it with him. He doesn't remember any Zaza now. Then there is my grandfather Hacı Baba's sisters: Asya bibi, Hami bibi, Gülli bibi, Ayşen bibi, whose names alone I know.

Then there is my grandmother, Hacı Anne. She died before my two sisters and I were born. I know her in a handful of photographs – her face a copy of my father's – and as a name whispered in prayers.

I think about what I know of Hacı Anne. I know that she had three sons and that health problems were the cause of her early death. I know that she and my dad had a relationship of extremes. My mum says that when they would go back, Hacı Anne and my dad would laugh so hard they would cry, in a way she hadn't quite experienced elsewhere. I know that Hacı Anne was heartbroken and inconsolable when my dad, her eldest son, moved to the UK. I know that one time when my dad was home, he bumped into her in the market during the day and they were so happy to see each other like that; to bump into each other in the market like that was an everyday thing that could happen. He smiles when he tells that story. I know that when my dad found out that his mother had passed away, he didn't believe it, and ran through the house and neighbourhood looking for her. I know that Hacı Anne's parents had a farm in the village of Bademli in the east of Turkey, near my grandfather's village, Pîran. Baba would go there in the summers as a child. Once we looked for the farm together on Google Maps on his iPad, and we traced the journey they would make together along the main road, Dicle Yolu. We were supposed to go there together in March 2020, but then the pandemic started. In our childhood home on the

Antrim Road, I remember Baba looking out the window and saying that lights in the distance reminded him of lights in the distance when he travelled with Hacı Anne between villages on horseback.

I decide to ask my dad about the rug; how it was that it ended up on the wall, where it came from, whether Hacı Anne and other women in our family made rugs. My parents are in New York visiting my older sister, Mevlüde, who is named after Hacı Anne, so I call my dad on Whatsapp audio. When he answers he tells me he is watching the England vs Ireland rugby match in the basement with Ibrahim, the oldest of my sister's three sons.

Oh that rug, he says, straining his voice over the sound of rugby fans blowing whistles. I suppose we didn't know where else to put it, he says. That's how it ended up on the wall.

There was nowhere else you would have put it? I ask.

It was tricky, he says. The other option would have been to put it in front of the fireplace, but then a spark from the fire could have caught on to it couldn't it. If we'd had wooden floors it could have worked like that but we didn't have wooden floors in that house did we, he says. So we put it on the wall.

I ask him where he got the rug and he tells me it's from the Dedeman Hotel in Ankara. They sold beautiful handmade rugs there, *el dokuma*. He bought the rug over forty years ago, before him and my mum got married. He remembers that he paid £25 for it.

I ask him whether any of the women in our family made rugs and he says no.

None of them made rugs?

No, unfortunately not, he says.

Hacı Anne sewed, didn't she? I ask.

Yes, oh yes, he says. She would have sewn, crocheted: covers for cushions, large covers for settees and beds. Mainly dantel. She once said she would have preferred to know how to read and write rather than sew, he adds.

69

Later I watch a video on YouTube where women of Yörük descent talk about the fact that their carpet-making trade is dying. They sit at looms as they are being interviewed, fingers moving quickly up and down their screens of wool strands, a blade in one hand making incisions so quickly that you can't see it happening.

Interest in buying carpets has declined. There's no one to buy and sell them, alan satan yok, one woman explains, her smooth, round face serious. She wears a neon pink cardigan with a black geometrical design over a green cardigan buttoned up. On her head she wears a white floral headscarf tied around her neck, with a multicoloured headscarf with silver sequins wrapped on top like a turban.

It isn't like it used to be, she says. We started learning when we were eight or nine, but now because the demand isn't there, the skills aren't being passed on to the younger generation. I know all the designs and motifs by heart, she says. My head is full of cranes and gazelles. There's only about twenty or thirty of us around here that can still do this work, once we're gone that's it – she wipes her palms together with a flourish and laughs.

I imagine the smell of her face and neck. I feel like if I kissed her cheeks, it would be in some way familiar. I think of all the aunties' faces I have kissed. I can imagine the smell of my uncle's wife's face as if she is sitting right beside me, a kind of musky comfort. I wonder do the faces of the other women on my father's side of the family smell the same. I realise days later that the smell is sweat and that I recognise it on myself sometimes. At least I am connected to my ancestors through sweat, if not through spools and looms.

I feel so close and so far from them at the same time.

I wonder later about the significance of the cranes and gazelles and skim through a page on the meaning of different rug motifs on a website called www.abc-oriental-rug.com.

A few weeks later, I am visiting my parents in Belfast and we pick up the rug conversation again.

Look, my dad says from his armchair in the backroom, you know they're handmade when you see the imperfections, you see there, the stripes in the red. That's a sign that it's not machine-made. We stare at the shades of red together.

You see with this rug, Baba continues, the bits that have seen the sun have greyed more than the bits that haven't. But your one is different, he says. The dye is fast, so the colours retain their hue. Decades haven't touched it.

I realise we've never really got to spend time with the women on your side of the family, I say.

Another way of telling handmade rugs from machine-made rugs is the tussles, my dad says, pointing at the rug with his fork.

Tassles, my mum says.

Tassles? my dad says.

Tassles, not tussles.

Yes, okay, the tassles. You can tell from the tassles. If you look underneath the rug and the threads feed into the tassles, then you know that it's handmade.

I ask Baba again about Hacı Anne. What did she like doing when she was sewing. She would have chatted or watched television, he says. She was into her TV dramas. He remembers watching her watching television with his oldest niece. They both sat open mouthed, agog at what was going on. She would take it quite seriously, he adds.

I ask him again about Hacı Anne. He swallows. I write and delete here many versions of a sentence that tries to describe witnessing the physicality of something suppressed.

She always wore those scarves didn't she, I say, the ones with the lace around the edges.

Yes, Baba says, yes. *Tülbent* they call that fabric. It's light and breathes easily so it would have been cooler in the heat. Google it, it's like muslin, he says.

I google it then and read him back different descriptions.

I am just full of remorse for not spending more time with her, he says after a while, his voice clear now. Time passes, but the judge inside is always judging you.

The next day I do a plank workout upstairs. I can't find a yoga mat so I do it on the rug in my bedroom, another handmade variety. During one plank I find myself staring at a tight, hard lump wedged in the rug. It stares at me like an eye as I hold my body above it. When I finish the workout, my forearms are red and raw. I touch the lump tentatively, worried that it might be a clutch of insect eggs. It's hard like an apple pip. I tell Baba about this later in the day.

That's a knot, he says, where the women will have paused for a break or a chat while making the rug. Maybe they were having lunch or a gossip, or a cigarette or a tea. We both laugh.

When I am writing this, I remember that my dad told me last year how Hacı Anne and her mother and other women would make *pekmez* – grape molasses – in the summers. I check the notes on my phone where I had written down some of what he said:

× She was the hardest worker so her parents would insist on waiting for her as she was the only one they trusted.

× She was like your mum, full of energy.

× They would crush the grapes in big concrete basins by stamping on them with bare feet and the liquid would drip into big metal trays.

× From the liquid they would make molasses and different 'goodies' – *sucuk, bastık*, etc.

I remember then that my dad announced in recent years that when it snowed when he was a boy, Hacı Anne would mix pekmez into snow and they would eat it together. It was

similar to a Slush Puppie, he said. I know that it snows a lot in the east of Turkey. I think about the coppery brown of the pekmez spreading through the white snow.

When I am back in London, I phone my dad to ask him about the journey on horseback he had spoken about when he looked at the lights in the distance from our childhood home on the Antrim Road. He pauses when I ask the question.

Was that from that house, or from when we moved to Templepatrick? he asks.

I'm pretty sure it was from the Antrim Road house, I say.

Are you sure? he asks.

I realise slowly in that conversation, and with great clarity in the aftermath, that he was completely right. The view at nighttime from our house on the Antrim Road was of Belfast Lough and a tapestry of lights across the city. The view at nighttime from our house in Templepatrick - an old farmhouse - was of complete darkness, with intermittent lights dotted here and there.

I think you're right, I say.

I think so, he agrees. We would have been making the journey back to Bademli from Pîran where Hacı Baba's family lived. There was one time in particular, he says, when we were travelling home to the village in the darkness. Hacı Anne and I on horseback, Hacı Maruf and some other uncles walking alongside us. Suddenly it started to rain, and quickly we were completely drenched. It was summer, he adds, so the rain was unexpected: harder than usual. We were desperately looking for shelter and finally saw an orange light in the distance. When we got there, it was a house. The family welcomed us in, and we all sat around the fireside.

What happened then, did you stay the night? I ask, thinking about 'In the Cart' by Chekhov.

No no, he says, we dried off for some hours and then continued on our way. There was no electricity in the villages

so the light we saw would have been the fire burning, or an oil lamp. In that sort of darkness any kind of light is distinguishable, he says.

Afterthoughts

I show the piece to my dad before it is published.

I am in London and he is in Belfast. I send it to him a couple of hours before I leave the house to meet a friend for dinner and check my phone every few minutes to see if he's replied.

I wrote it knowing I would share it with him, but still feel anxious.

Who am I to have written this?

I remind myself who I am to have written it.

I don't hear from him so I ring him on my walk to Green Lanes for dinner. I ask him what he thinks of it and he says he likes it, that I've done well. He has a tremor in his voice. He says he was just making a few notes of some edits. I'll tell you them now, he says.

He tells me that firstly the rug cost £25, not 25 TL, as I had initially written.

He tells me that I had combined two separate events – the pekmez making and the journey on horseback at the end. The two things are separate, he says.

I say, that's good to know, I didn't realise. Then I say, no one else will know that though! As I say this, I realise that that isn't what is important and later make edits to correct this.

He suggests that I make the Turkish words italics or put them in quotations. I say I'll think about it and then add that, actually, the publishing world is moving on – we don't owe 'legibility' like that.

People can google things, I say.

I'm not suggesting you translate, he says, but it's helpful to be clear.

I'm on Green Lanes by this stage; the traffic is loud and I say I'll think about it, cupping my hand over my phone.

My mum messages me telling me how much she likes the piece. At the end she writes, You know Hacı Anne trained Perihan [my aunt] in cooking so you have all tasted her food.

Later I let my mum's words sink in, reel at the fact that I had not previously known this. I imagine the dishes that my aunt serves, one by one.

My dad follows up with a final correction. In the making of pekmez, the liquid from the grapes didn't *drip* out of the concrete basins, it *flowed*, he tells me. There was a spout and it flowed out of that.

Imagine a flow from a spring, he says. That kind of flow.

I think about my grandmother, her bare feet trampling over grapes.

Sweet juice flowing from her feet.

FLOWERS
David Keenan and Heather Leigh in Conversation

*Someone lies in bed, staring at a record sleeve, a square of
possibility mystery glamour joy thrills badness, someone
sits in their living room, listening to transformational
sound that transports to someone who sits at a kitchen table,
gazing, gazing at a vase of flowers – how beautiful, how
strange! How beautiful.*

*Eavesdrop, because you can, on a conversation between
David Keenan and Heather Leigh, where they gently
trace some significances, memories, and experiences in
relation to the psychedelic presences of music, sleeves,
and flowers.*

DK I want to ask you, what is your favourite flower?
That was going to be my first question but somehow that got
confused in my mind and I thought I was going to ask you
what your favourite psychedelic record sleeve is. I don't know
why that's getting confused in my mind. Maybe it's because
I'm thinking of you and I'm thinking of Texas and thinking
of 'Twisted Flower' by Cold Sun.

HL My favourite psychedelic record sleeve ...

DK Or flower.

HL My favourite psychedelic flower or record sleeve ...

DK Or just flower because all flowers are psychedelic.

HL Some flowers are more psychedelic than others.

DK I don't even know if I am asking you which is the most psychedelic. I am asking you, maybe, about your favourite in two genres of psychedelia, flowers and album sleeves.

HL You bringing up Texas psychedelic makes me think of course of The Golden Dawn, *Power Plant*. Because I do love that sleeve. It's really lurid, with hot pink flowers.

DK Do you think a lot of your favourite psych records are probably Texan?

HL The 13th Floor Elevators, Red Krayola, Cold Sun. Those probably all mean more to me than, if I'm being honest, any Jefferson Airplane records.

DK Golden Dawn, Bubble Puppy too I guess.

HL Golden Dawn, Bubble Puppy. Well, the Texas psychedelic, first of all, is quite fried. I mean, it's really the full extreme of psychedelia. It's not Donovan psychedelic where it's somehow lighter than the clouds. The Texas psychedelic has a darker edge. There's a hint of biker in there and blues. Really deep blues, heat, humidity.

DK I think there's a religiosity to psych.

HL Yeah, I would agree with that.

DK It almost doesn't come in anywhere else. I mean, I know you could say that the West Coast is obviously involved in that as well. But there is something about the Tommy Hall-isms, *Easter Everywhere*, the back sleeve, *The Psychedelic Sounds* - I mean, if we are talking about the greatest psychedelic record sleeves of all time, is it the first two Elevators albums?

HL Yeah probably. I do love Red Krayola, *The Parable of Arable Land*. I have a real soft spot for that one too. But yeah, the first two Elevators albums, it's hard to argue with that.

DK What about Texan flowers?

HL Bluebonnets. Bluebonnets are everywhere. And it's traditional when they come in, in the spring, that you go and get your photo taken. And a blanket of bluebonnets; you have to crouch down among them.

DK I think there's something about blue flowers that always reminds me of childhood. Because I think of even the notion of flowers being blue, you know what I mean, it's quite psychedelic. I mean, I was like yellow, white, red, you can kind of understand –

HL Even pink –

DK But a blue flower – I think that's why maybe the first experience I ever had with really loving flowers would have been blue flowers. It probably was when we went for a day out from school. This was when I was living in Shettleston in the east end of Glasgow. And we went on a day out from school and well, they called it the Bluebell Woods, but it was just a little patch of trees heading up towards what they called Calderpark Zoo, because there was a zoo really near my house whenever I was growing up. I mean obviously it was closed down long ago, it was pretty gnarly, but I remember going out for this trip to the Bluebell Woods. We were going to the Bluebell Woods and it seemed magical. And of course we were going to this patch right next to a street, a road, but there were bluebells all over the ground. And I can remember sitting among them and picnicking –

HL Yeah there's something about the sitting among them.

DK And even, it was the blueness!

HL Yeah ... yeah! A sea of flowers. I can picture in my
mind exact photographs of me crouching down in bluebonnet
fields and even being frustrated at some of the photographs
where I feel that I'm not crouched low enough. You know, I
worried that we don't get the effect of how swarming they are.

DK What, you're not low enough, in that you want them to
lap over you?

HL Yeah, I want to be lost in them. I can remember a
photo – the wind's blowing and my hair's quite short. I'm
probably eight, or something. I'm wearing pink shorts and
a white and pink striped top. And I'm leaning where I have
one knee on the ground and the other in front of me. With
my foot flat on the ground. And that's the one I'm thinking
of. I'm not quite immersed enough.

DK Still, the author in her element.

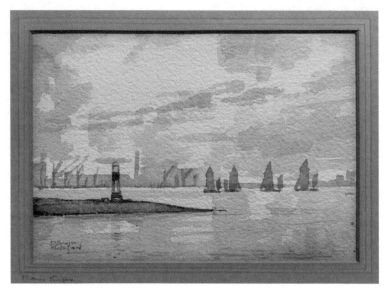

David Wilson (1873–1935), *Thames Barges*, 1920. Watercolour on paper, 15 cm × 20 cm. Private collection.

UNHEIMLICH MANOEUVRES
Shaun Whiteside

The tiniest of drawings, capturing a moment. A child takes
its first steps, supported by two girls, viewed from behind,
while a figure crouches encouragingly in front and a woman
carrying a bucket – a milkmaid? – looks on. Drawn in thick
strokes on paper, it records an event of everyday triumph and
tenderness. The older children will have taken their own first
steps not a long time before. You wonder what became of
them all. On the reverse of the same piece of paper Rembrandt
wrote, again in brown ink, a question concerning a certain
Meneer Thyssen about whether he actually wants either of the
two paintings finished if he doesn't really want the paintings
anyway. It's a miracle that this scrap of paper, titled *A Child
Being Taught to Walk* (ca. 1660), has been handed down to us.
It would look great in our hall, beside the coats. So, in fact,
would any number of Rembrandt's drawings or etchings –
those extraordinarily intricate Dutch landscapes, a bit of
scrubland, some trees, a cloudscape, a canal, a man fishing,
perhaps a pair of lovers glimpsed off to the side, and a
windmill in the distance. Impossible not to think, if only for a
fraction of a second, when you see them in the Rijksmuseum
or anywhere else: do you think they'd miss just one? They cry
out to be owned in a way that a huge and opulent Rubens or
something like *The Night Watch* doesn't.

In 2008 the British artist Roger Hiorns (and his team,
I assume; he can hardly have done it all by himself) sealed
an abandoned bedsit in the Elephant and Castle district of
South East London and filled it with 75,000 litres of boiling
copper sulphate solution. Some months later, *Seizure* was
opened to the public who, after donning boots and a helmet,
found themselves in a curious wonderland, a lapis lazuli,
sparkling grotto that smelled like a chemistry set. The

crystals had formed not just over the walls and ceiling, but also over door handles, sinks, baths, and long-disused light fittings. This is a transformation of the domestic space into something unhomely, *unheimlich* or uncanny, to use Freud's terminology. There was a vogue for such unsettling interventions around this time – think of Gregor Schneider's *Die Familie Schneider* a few years previously. This one involved two identical terraced houses side by side in the East End of London, with identical actions being practised inside, all day: a woman desultorily washing up, a man pleasuring himself in the shower, a seemingly feral child crouching among bin bags. In this case puzzled art-goers were sometimes prompted to react with aggression, even violence towards the actors. Again it's the displacement of the surreal or the unexpected to the domestic sphere. It's not impossible to imagine similar interactions within the private sphere: a Tino Sehgal player suddenly appearing in the sitting room to ask you politely, and in that slightly sinister way, what you mean by art, or what you mean by meaning, as in Sehgal's work during his residency at the Stedelijk Museum in Amsterdam in 2015; or Martin Creed's lights going on and off (*Work No. 227: The Lights Going On and Off*), which won him the Turner Prize in 2001. I think I'd go for the Sehgal out of those two, although the Creed would obviously be easier to install.

On the other hand: David Wilson's little watercolour of a Thames barge race near what appears to be Woolwich Dock – again in East London and not far from the site of Punchdrunk's Troy-based immersive drama *The Burnt City* (2022), itself a recreation of domestic spaces within a vast former arsenal, a place to get lost in, a place to rifle through private papers and weigh ornaments in your hand, a place to encounter performers sobbing, making love, or slaughtering one another – hung unnoticed for years in what was once my father's brewing room in our home in County Tyrone,

the place where, according to the season, he would make his elderflower or elderberry wine in a (what seemed to me) huge plastic tub, the same room where once (perhaps in 1972?) the four bottles of ginger beer that I had made as an experiment all exploded within seconds of each other while we were watching television downstairs. There it hung with others: more barges – he liked barges – a painting of Swinburne's house (now an old people's home), and a small painting of an unprepossessing coal bunker perhaps somewhere in South London (the coal bunker is not the most obviously attractive of his works; not only is the subject matter resolute, but the perspective used is puzzling and oblique). The barges look ghostly, little smudges of brown against a pale sky, with the docks sketched in as an unshowy setting. Born in County Tyrone and raised in Belfast, Wilson worked as an illustrator and painter in South London, a stone's throw from where I now live and where his painting hangs, and he would have been setting up Streatham Watercolour Society at around the same time as his brother, my maternal grandfather, was in Saskatchewan trying his luck as a cattle farmer and reputedly living in a sod shack, whose floor he would lower in order 'to raise the roof'.

This watercolour, with its muted palette, commonplace subject matter, and minimal insurance value, establishes a link from home to home and generation to generation. There are a few Thames barges still around – we sometimes see the *Greta* sailing out of Whitstable, and I wonder if she might be one of the boats in the painting. Thames barge races still happen in the Thames Estuary, although not with such frequency or in such numbers as in my great-uncle's day. One day we may even go and see them.

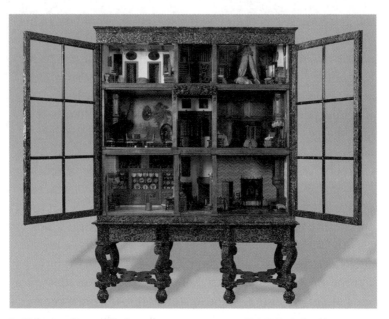

Doll's house of Petronella Oortman, anonymous, ca. 1686–1710. Oak cabinet, glued with tortoiseshell and pewter, 255 cm × 190 cm × 78 cm. Courtesy of the Rijksmuseum Amsterdam.

AN EMAIL RECEIVED FROM A READER ABOUT A SHORT STORY
Philip Mann

The reader is the writer, Philip Mann.
The reader of the email is the writer, Wendy Erskine.

I thought 'Locksmiths' was a very good story indeed not
only because of its sparsely laconic tone ('she died the way
she lived: in front of the telly' made me laugh out loud) but
also because it can be read on at least two levels. On one level
the house itself is the main character and it is a story about
taste with all its sociological implications. I imagine the
house as a '60s council house but still very much in line
with the precepts of the International Style and the modern
movement (if dark brick as in the British variation).[1] While
Le Corbusier et al had conceived the bulk of their housing
projects as social housing, the recipients of their 'patronage'
were more than often unhappy with the Spartan aesthetics
imposed on them and sought to cosify the interior with
wallpapers, crocheted table covers – the lot: to make them
gemütlich to the great dismay of the architects. Presumably
the grandmother did just that and the jailbird daughter was
hoping to come home to an updated version of just that. You
introduce that theme with the trip to the DIY store – only later
does the reader realise what the insistence on simplicity and
indeed 'brilliant white' is all about. So in that sense, and
without any of the ambiguous implications of class-mobility,
it is a story of taste evolving by going back to the purist
intentions at the inception of the house – vegetarianism and
teetotalism included.

On the other level, which to most might be the more
obvious one, I see it as a story of maturity inverted. The
grandmother – likeable as she is – is the baby, living a simple

life of TV (sleeping), whiskey (the bottle), and cigarettes (nipple, parental affection, etc.). The not quite homecoming mother is the horrendous and eternal teenager who in the throes of self-indulgence has done something truly awful more or less accidentally. This in turn has caused the narrator to be the apparent adult of the three. Apparent, because her maturity is entirely reactive. She's been robbed of the naivety of childhood too soon and too abruptly – 'they fuck you up your mum and dad, they don't mean to but they do' – though in this case the 'don't mean to' is criminal indifference. So that connects the generational level seamlessly again with the taste level: the narrator has 'good taste' because she has realised the existentially perilous implications of 'bad taste'. The Spanish prologue had of course already introduced the two levels beautifully: house as object, protection, and indeed location of intense existential drama.

1 In truth, the house was imagined as a two-up, two-down Victorian terrace of the kind found in cities like Belfast and Manchester. There is, however, no textual evidence to support this in the story, which therefore renders the idea of the '60s council house as equally valid, and in fact, a preferred reading since it gives rise to those issues of taste, art, and aesthetics, detailed in the, gratefully received, email. - Ed.

Jo Broughton, *Empty Porn Set Christmas July 2015*, 2015. Photograph.
Courtesy of the artist.

ADULT MOVIE
AFTER JO BROUGHTON
Susannah Dickey

1

Wordless - most pleasant

Factual - least pleasant, worst remembered

Two performers do not enter. The two performers are
not presented with the scenario: Christmas salami carpet.
[Not gonzo.]

Emotional - pleasant, best remembered

The bifurcation of a world by the world's end and the
seamed softness of the fourth wall's nipple that breaches
proscenium, outsteps narrative. No scene self per se.
An instruction manual for naked semaphores sits on one
of the set's two floors and beyond the patio doors it's
Christmas and a thrusty herm carries a dying snowman
from a mountain. What do I gain by suspicion? And so:
away, questions! Cast my Saturn shoes aside! Despatch
my pants to the moon!

Wordless – most pleasant

.

Factual – least pleasant, worst remembered

A third performer does not enter. The third performer does
not watch the actions of the first and second performer
from behind the Christmas tree.

Emotional – pleasant, best remembered

[In keeping with the strict building codes, smoke alarms
were installed on each of the interiors of the four exterior
walls, seeing as neither the interiors nor the exteriors of
the two interior walls possessed interstices equipped with
wiring. Three of the alarms commenced a syncopation on
a Thursday and their timbre was such that the performers
in the magazine altered their rhythm. Annoyed by this
encroachment onto the unreal world, and the real world,
of the unknown, she kicked off her silky shoes and silky
pants, took the alarms from the walls and ate them.]

The lights that light life come from apocryphal sources!
Chirp! Imagine! Trap a sun in an hourglass and ask
that it illuminate the way to a tea-marked toilet! Chirp!
Madness! And yet there's an untraceable brightness that
shirks the east-west arc, that casts the sky as a paucity,
that demarcates the natural from the real! Chirp! A lark
in a sock drawer, a sophistry! A sound that pricks my
exteriors! I wonder if it's coming from inside me!

Wordless – most pleasant

.

Factual – least pleasant, worst remembered

The second performer does not make the first performer
a drink using the cocktail shaker. The first performer
does not sit at the sofa's edge, furthest from the tree, and
remove shoes. The third performer does become flushed
at the sight of the first performer's bare feet.

Emotional – pleasant, best remembered

Plumpen gold cushion! Gifts and dildos! Bows and
buboes! – oh! – Piggy eyelid and the reflection of a snow
globe's coma fantasy! In an empty box, wrapped! When
animated my hammy disc will dizz betwixt protagonists!
When animated my swiney O moves faster than the downy
throw: such is parallaxis!! My praxis is to cast all things
as urns and go from there: the silver urn casts shadows
on the wall's second white, its placket: next to it's the ice
bucket: another urn. Tucked by the sofa is the return of
the plotty dildo – my long gold urn, my monolith: ode on
secretion urn! Perpendicular to molten blossom! In there
is where I eat my sundries!

Wordless – most pleasant

.

Factual – least pleasant, worst remembered

The first performer does not remove clothing. The first
performer does not use the dildo for self-pleasure. The
second performer does not consult the magazine on the
floor. The second performer does not find themselves
within the magazine's pages and commence weeping into
the ice bucket. The third performer does not unwrap a gift
then return outside to become whole.

Emotional – pleasant, best remembered

I want to make a sundial of me! Gnomon of this pink and
steamrolled knoll! I'll assemble it and sit and make an
evening in this timeless! Not this timeless, but this stasis!
In this space I'll be a banana in a reliquary, sandwich in
a gallery! Set spile to fleshy tree and summon brand new
forms of me! In the lurex jerricans beneath the tree are
the promises of pleasant sadness and I'll gift them to
myself, to the ice bucket, to the puddle, once an onlooker!
Oh! Let loose the scrim that makes me lose track of all
my mes – let be me worm, let me be seeing self! There
once was something like sex within this set's cold rinds
and how I felt it – I've never had it but I'll feel it! This
perfect pleasant worldlessness is tinsel for the mind!

Wordless – most pleasant

.

Factual – least pleasant, worst remembered

A leak from an unseen pipe does not commence dripping.
The first and second performers do not interrupt their
heavy petting to investigate the cause. They do not get
increasingly anxious at the source of the leak seeming to
be external to their reality. The third performer does not
arrive, now dressed as a plumber.

Emotional – pleasant, best remembered

Oh! Algaecide glow on wipe-clean linoleum! I cannot know
what farrago of gods sent you! The curls of my sybaritic petals
unfurl at your arrival! Leucism of floor calling for fluid! Let
me play like umbel on pond's edge! Let me meet the wibbling
twin that walks reflectively with grace! Oh! The fractals
of reality aren't pleasure's enemy! Plumby! May I call you
plumby? Set down your glue closed case and nudge your work
boots to urn's precipice! The sap that leaves the Christmas
tree is glucose from some agave! Plumby, let this conceptual
asparagus pierce your heart: the gauze that lines our windows
is no impediment to gaze, but you can't have thought ours
was a life not made for being watched! Oh plumby, my
former snow-made sweet-skinned plumby! We don't even
have a table! Let's make a life despite our only half a salami
slice rug! Let's hold these shiny cushions fast and wiggle!
Please, resected world, let the echoes of myself know touch;
let even just the uppermost so those embedded might get a
whiff! Plumby, fear without skin is a hat box filled with lice.

Photo: Jan McCullough

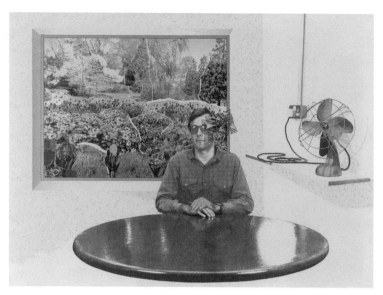

Tim Mara, *Picture Window*, 1980. Multicolour screen print, 76.3 × 107.3 cm.
Collection Irish Museum of Modern Art, Gordon Lambert Trust, 1992.

TIM MARA
Nicole Flattery

Firstly, I like how cluttered the artist's prints are. The abundance of objects and the confusion these objects generate feels very real to me. I often spend my days asking: how did that get there, who turned on the television, where has all this stuff come from? I'm convinced it's not a symptom of my disorganisation but, in fact, how everyone feels.

Secondly, I like how dismayed his central figures appear to be. A man sitting in front of a fan at a blue table, an unconvincing, too perfect garden looming behind him. He's so ordinary that if you look for long enough, his ordinariness starts to become sinister. He is a spy. He is a hitman. His glasses on, a standard brown shirt, his hands politely folded. A pose of quiet despair or utter obliviousness. I can't decide. In another, my favourite, a girl sits in a room that reminds me of my grandmother's 'good room' – the same glass cabinet, in which she stashed all of her most untouchable, precious objects, the same air of chilly obedience that room demanded. The Kellogg's Corn Flakes box is the perfect addition. Corn Flakes are what you ate when you were told, before you realised there were other things you could eat, before you had any independence at all. The objects in the artist's work seem random at first glance – used only to suggest the overall effect of 'busyness' – but they aren't. His work is too thoughtful. In the middle of the room, the girl sits with long hair and a short, short skirt. She wants to have fun, but who could have fun in a place like this? And the boots! Boots that no one could ever actually wear, boots that could only appear in a sexy space-film directed by some lunatic French director. In this girl's mind, she's already gone. Her pose challenges the viewer, 'You don't actually think I belong here, do you?' Both of these figures' worlds have become uninhabitable to them,

99

one way or another. You can tell. They've just chosen different escape routes.

There are domestic scenes, saturated in colour, but they're not cosy. In several of them people are turned away, reading newspapers, disconnected from each other, even if they are in the same room. The part the media plays in our culture, our lives – although I doubt he could have predicted the frenzy it has now reached – is an idea that runs throughout his work. The static televisions, sometimes more than one appearing in a print, the magazines, the piles of records: these are the detritus of life, but is he not saying something more? That's what everyone wants to know, isn't it: if the artist is saying something *more*? His prints, with their very specific sense of humour, reject this tedious idea. In another, a man lies beside an abandoned picnic with a tabloid newspaper covering his face. The headline reads, 'My Holiday with Strip King'. Now, this is very Pop art although the artist has rejected all comparisons with Pop. Although the influence is absolutely there, his work is less self-serious than a lot of Pop art, more interested in lived experience and narrative rather than making a grand statement. There was a lot of ego in Pop art, masked under irony and glibness.

I know this because for most of 2019, all I did was look at Pop art. Pop paintings from the sixties and seventies, the photographs, the images, the acres of acres of *stuff* that movement generated. I was writing a book set in the Factory and like anybody who doesn't know what they're doing, I was trying to find a way in, as if my own (unwritten) novel was a case I was attempting to solve. I went to a Warhol exhibition in New York; I saw Pop paintings in Paris, Dublin, London, anywhere they were available. I'm sure Pop art isn't meant to be consumed this regularly or in this abundance, certainly not Warhol's. Well, they become repetitious. The ideas are there but the feeling is not, and without the feeling it starts to become numbing. Critics would argue that with Warhol there

was never any feeling in the first place. Still, I went. I had a routine: I'd view the work, then I'd go to the café, and, in my own inconspicuous black notebook, I'd try to come up with something new, original, and dazzling to say about the most written-about artist of the twenty-first century. Usually I'd end up in the gift shop; that's where we all end up in the end. Pop art was just something to buy now. I felt nothing towards it. Maybe that was the intention. Warhol was a big fan of nothing.

Around this time, my father told me his cousin had been an artist. I'm sure I'd gotten this information somehow before, but I hadn't been paying attention or, since life then didn't revolve around galleries and gift shops, I had forgotten it. I was more interested now. When I googled Tim Mara and went through the online images, I was thrilled, giddy, high. I was saved. I wasn't foolish to try and write a novel about the Factory: Pop art ran in the family. Tim Mara was born in Dublin and lived most of his life in London. He attended Wolverhampton Art College and the Royal College of Art, London, where he subsequently became Professor of Printmaking and Head of the School of Fine Art. His work is included in collections at the Tate and the Victoria & Albert Museum. These are biographical details I've gathered from online: he died in 1997. Looking through his work, I remembered what it was like to feel something for art again. There is an openness, but a secrecy too. He has no interest in telling you everything; he trusts the viewer's intelligence. He isn't winking at you either. I came across, again accidentally, another print of his in IMMA and I felt spontaneous joy. I looked through so much of his work that I finally began to see it for what it was: work. The labour that's involved in a process as complex and layered as screen-printing. Inspiration, what I'd been idly waiting for in the gallery coffee shop, isn't enough. Through his work - work I urge you to go and seek out - I absorbed some of his incredible energy and focus when I most needed it.

SPENT LIGHT
Lara Pawson

As Coventry is twinned with Volgograd, so your silver tankard
is twinned with a moth trap. Its adhesive surface ripples
and glistens, a little like Monet's lake with the water lilies
I suppose, a thought that occurred to me when I saw someone
talking about the artist on the *Antiques Roadshow*. But the
gloss of the glue on the moth trap has been ploughed with the
straight strokes of a machine, not the hand of a man working
for years to capture the reflection on water of the sun and
the clouds.

Held within a piece of plastic not quite the whitest of
whites, this kit for killing is a monument to shadow and light.
The longer I look at it, the more convinced I am it was created
by Louis I. Kahn. A by-product of the Jatiya Sangsad Bhaban,
the huge parliament complex he designed for Bangladesh.
Not that I know much about the great architect, beyond a
few facts.

I know that he was born Leiser-Itze Schmuilowksy in the
Estonian city of Pärnu in 1901. I know that, as a toddler, he
burned his face after picking up hot coals from the fire,
having been attracted by their light. And I know that, in 1906,
his family emigrated to the States, to Philadelphia's Jewish
ghetto, where they lived in and out of poverty. I also know
that I admire his devotion to geometric shapes. I love the way
his lines recede from circles, the way he frames circles inside
squares. And I know that I can ask this piece of plastic, What
do you do, plastic? And plastic replies, I like an arch.

I keep having these moments when I think I can see Kahn's
scarred face. He's standing at a desk, a thick pencil in hand.
His eyes are softening and he's drawing an opening of some
sort. It's inspired by the grapefruits he released into a bowl.
When the circle is complete, he surrounds it with six arches,

each modelled on the wider end of the pale blue egg that was laid by the lone cream Legbar pecking about next door.

Inside this sculpted hangar, beneath the symmetry of simple shapes, shadows come and go beside small blocks of light. Even the most reluctant eye could not resist to gaze upon its surface – almost unbearably smooth, like the poured resin that smothers the kitchen floors of those who stroll over Hackney's London Fields.

The first time I encountered this type of moth trap, I was browsing in a large shop beneath the tarmac of Oxford Street. I passed a personalised dog bowl made from oak and stainless steel and priced at a hundred and fifty-five pounds. The emphasis here, in this flattened space, was upon a sterile aesthetics of home, upon the appearance of absolute hygiene, upon a certain discretion of death.

Far better to turn to Kahn, who believed that a room has religion, that a room is a world within a world. He believed that we are all made of spent light. Microbe, moth, man – we all have something to express. He believed that before a building is built, there exists a tremendous will and that, at this stage of nothingness, the building is at its best.

Once it is built, it is locked in servitude. It wants to tell you how it was built, but can find no one to listen. A building is only good, thought Kahn, if its ruins will be any good. He was discouraged by those who thought about buildings in terms of functionality. A building is a spirit, he said. It is made out of man. A moth trap is a spirit too, I say, and it is made of man.

A slice of the sun filters through the space of the trap, which lures in life and sticks it still. These tiny moths, these delicate creatures, whose wings are made of silver silk, their bodies threaded with gold. The moth trap holds tight in glue these beautiful, shimmering things.

Stuck down, they turn brown. They will never fly nor flutter again, these creatures with their extravagant, feminine name: *Tineola bisselliella*. Should they not die upon gold leaf?

104

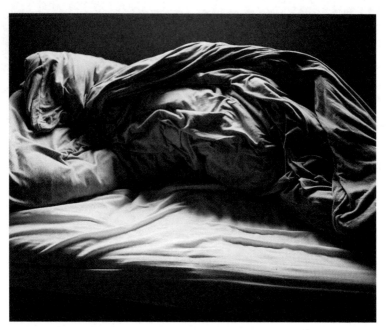

Gareth McConnell, *Meditation IV*, 2003. Courtesy of the artist.

Latifa Akay is a writer from Belfast. Her prose and poems have appeared in places including *The Good Journal*, *Popshot* magazine, and *Poetry Birmingham Literary Journal*. She lives and works in London and formerly worked as a journalist in Istanbul.

Mauricio Alejo, born in 1969, is an artist working across media who has exhibited internationally. His work explores the relationship between objects, space, and the elusive nature of images.

Darran Anderson is a London-based Irish writer. He is the author of *Inventory* (Chatto & Windus, 2020) and *Imaginary Cities* (Influx Press, 2015).

Richard Billingham is an English artist, photographer, filmmaker, and teacher. He was the first recipient of the Deutsche Borse Photography Prize (1997) and was nominated for the Turner Prize in 2001.

Jo Broughton is a London-based documentary photographer and artist who trained at the Royal College of Art. She is currently working on a self-published book that comprises her series of photographs *Empty Porn Sets*, which were shot over a decade.

Rossa Coyle is a writer based in Belfast. She has a BA in English from Trinity College Dublin and is currently studying for a BSc in Psychological Trauma at Queen's University Belfast.

Susannah Dickey is a writer from Derry. Her new novel is *Common Decency* (Doubleday UK, 2022), and her most recent poetry pamphlet is *Oh!* (Lifeboat Press, 2022).

Emily Dickinson (1830–1886) was an American poet.

Wendy Erskine's two short story collections, *Sweet Home* and *Dance Move*, are published by the Stinging Fly Press and Picador.

Nicole Flattery's work has appeared in the *White Review*, the *Stinging Fly*, and the *London Review of Books*, amongst others. Her story collection, *Show Them a Good Time*, was published in 2019. Her novel *Nothing Special* will be published in March 2023.

David Hayden was born in Ireland and lives in England. His writing has appeared in *Granta*, *A Public Space*, and *Zoetrope All-Story*. His first book is *Darker with the Lights On*.

David Keenan is the author of six critically acclaimed novels and a winner of the Gordon Burn Prize. His latest book is *Industry of Magic & Light*. He lives in Glasgow, Scotland.

Heather Leigh is a musician, songwriter, artist, and gardener who lives in Glasgow, Scotland. Her most recent solo albums are *I Abused Animal*, *Throne*, and *Glory Days*.

Born in Germany, Philip Mann has lived in London for thirty-two years. He has written for *Frankfurter Allgemeine Zeitung* and *Vogue*. His book, *The Dandy at Dusk: Taste and Melancholy in the Twentieth Century*, was published by Head of Zeus in 2017.

Gareth McConnell is a UK-based artist. His practice has been given recognition in monographs, cover features, and articles published by *Steidl*, *frieze*, and *Aperture*, amongst many others.

Jan McCullough is an artist based in Belfast, Northern Ireland. She works with photography, moving image, sculpture, and installation.

Lara Pawson lives in London. Her first book, *In the Name of the People*, was an investigation into a massacre in Angola. Her second, *This Is the Place to Be*, was a fragmentary memoir. Her third is still in progress: it is a hybrid work inspired by objects.

Keith Ridgway is the author of *Hawthorn & Child*, *Animals*, and other works of fiction. His most recent novel, *A Shock* (2021), is published by Picador and was awarded the James Tait Black Memorial Prize for fiction.

Joseph Scott is from Belfast, Northern Ireland. His work has been broadcasted on the BBC Ulster Radio. He is currently studying for a Master's in Creative Writing at Queen's University Belfast.

Frances Stark is an interdisciplinary artist and writer, whose work centres on the use and meaning of language, and the translation of this process into the creative act.

Annelies Štrba is a Swiss multimedia artist who works with video, photography, and digital media.

The Dutch artist Maurice van Tellingen depicts seemingly unimportant moments from reality. But dissected and reassembled into works of art, they overcome the mundane and become magical and universal.

Joanna Walsh is a multidisciplinary writer for print, digital, art, and performance. The author of eleven books, she is a UK Arts Foundation Fellow and Markievicz awardee.

Shaun Whiteside is a writer and translator who has worked for many galleries, art publishers, and art journals across Europe. Born and raised in Dungannon, County Tyrone, he now lives in South London with his family.

First published in 2022 by PVA Books

'In the Kitchen' by Wendy Erskine was originally
published in *Kaleidoscope II* (2021).

'Rothko Eggs' is an excerpt from Keith Ridgway's
Hawthorn & Child (Granta, 2013).

'The Architect and the Housewife' by Frances Stark
was originally published in the eponymously titled
book (Book Works, 1999).

'Art' by Joanna Walsh was originally published in
Seed (No Alibis Press, 2021).

ISBN 978-1-9161509-3-5

Designed by Daly & Lyon, London
Printed and bound in Estonia by Tallinn Book Printers

PVA gratefully acknowledges the support of
the Arts Council/An Chomhairle Ealaíon.